DESPERATELY SEEKING FRIDA

IAN CASTELLO-CORTES

GINGKO PRESS

BEGINNINGS

Frida Kahlo was very much her father's daughter. As with so much of her life, this was a paradox: the daughter of a German émigré who yet later played up her *Mexicanidad*: her indigenous roots, via her maternal grandfather. Christened Magdalena Carmen Frida, she chose to use her Germanic third name. One suspects that Frida was an accomplished mythmaker from an early age, and growing up in what was a cosmopolitan household in a time of flux, together with a photographer father who created studied images, would have rubbed off on her. Feisty from the start, Frida never felt she had to think like the pack, and understood the power of contradiction. She was different; getting polio at the age of six made her more so. It was an intensely interesting time to be growing up in Mexico. The Kahlos lived a comfortable bourgeois lifestyle in the most charming pueblo of Coyoacán, then on the western edge of Mexico City. All this was to be disrupted by the Revolution: ten years of a vicious civil war which has long since been forgotten.

❶

BADEN-BADEN

"Frida, lieber Frida"
Guillermo Kahlo's sing-song to little Frida

No one is more an icon of Mexico and *Mexicanidad* than Frida Kahlo. Yet the truth of her origins is a little more complicated. Her grandparents on her father's side were Hungarian émigrés from Arad (now in Romania), who settled in the chic German spa town of Baden-Baden. Jakob Kahlo was a jeweller and photographic equipment supplier for enthusiasts of the new art form. In 1872, Wilhelm, Frida's father was born. Jakob's business did well, and he sent his son to study at the University of Nuremberg. In 1890, however, two disasters struck. Wilhelm suffered a fall which sparked off serious epilepsy and then his mother died. Jakob remarried quickly and packed Wilhelm off in 1891 to Mexico. Wilhelm changed his name to Guillermo and never saw his father, or set foot in Germany, again. But the fact remains that Frida was, for all her *Mexicanidad*, half German, and this cosmopolitan quality was a critical part of her makeup. Christened Magdalena Carmen Frida, Frida wished to be known by her third, very Teutonic name, which at first she spelt 'Frieda'. Her first schooling was at the German school in Mexico City and she also chose to keep her maiden name all her life.

②

LA CASA AZUL 1

"I have my father's eyes and my mother's body." Frida

The one storey stucco Casa Azul in Coyoacán, then a quiet residential pueblo on the outskirts of Mexico City, was where Magdalena Carmen Frida was born on 6th July 1907, to Guillermo Kahlo and Matilde Calderón Y Gonzalez, the third of six children. Guillermo had built the house in 1904, following a somewhat colonial pattern, after the initial success of his photographic venture. Matilde and Guillermo had met at work, at a jewellery store, La Perla, in Mexico City. Tragedy had visited them both: Guillermo's first Mexican wife died after the birth of their second child. Matilde's first boyfriend, also German, had committed suicide in front of her. So Frida was born into a family full of complexity, who had their share of emotional and other crises, and where her father's epilepsy and attendant mood swings cast a shadow. But it was a creative household. In addition to his photography, Guillermo was an amateur painter and a keen pianist: strains of Brahms and Beethoven would waft through the house every evening.

WHERE?
THE COURTYARD GARDEN,
LA CASA AZUL,
COYOACÁN.

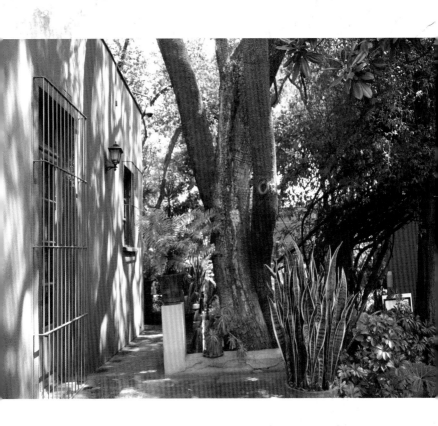

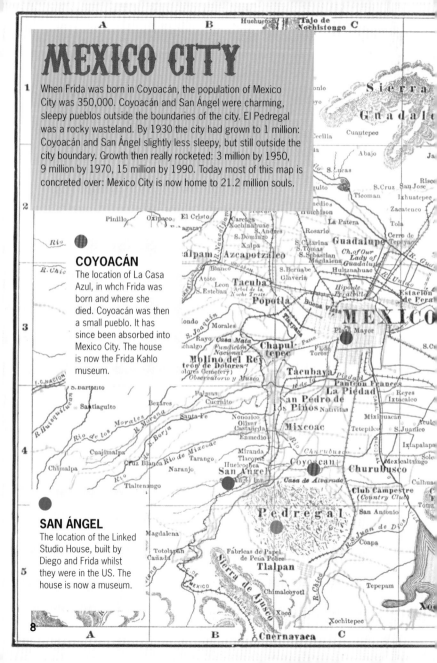

MEXICO CITY

When Frida was born in Coyoacán, the population of Mexico City was 350,000. Coyoacán and San Ángel were charming, sleepy pueblos outside the boundaries of the city. El Pedregal was a rocky wasteland. By 1930 the city had grown to 1 million: Coyoacán and San Ángel slightly less sleepy, but still outside the city boundary. Growth then really rocketed: 3 million by 1950, 9 million by 1970, 15 million by 1990. Today most of this map is concreted over: Mexico City is now home to 21.2 million souls.

COYOACÁN

The location of La Casa Azul, in whch Frida was born and where she died. Coyoacán was then a small pueblo. It has since been absorbed into Mexico City. The house is now the Frida Kahlo museum.

SAN ÁNGEL

The location of the Linked Studio House, built by Diego and Frida whilst they were in the US. The house is now a museum.

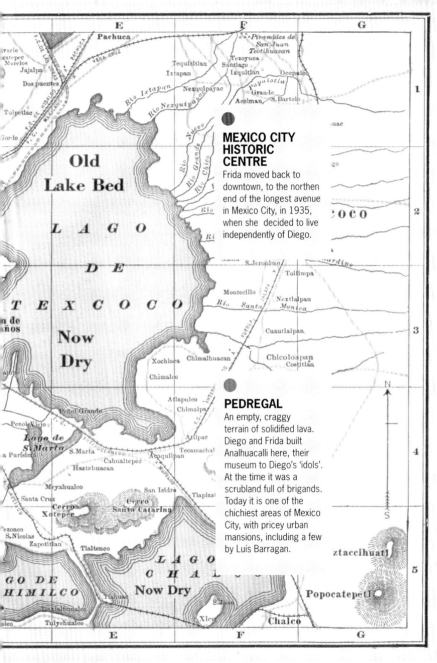

MEXICO CITY HISTORIC CENTRE
Frida moved back to downtown, to the northen end of the longest avenue in Mexico City, in 1935, when she decided to live independently of Diego.

PEDREGAL
An empty, craggy terrain of solidified lava. Diego and Frida built Analhuacalli here, their museum to Diego's 'idols'. At the time it was a scrubland full of brigands. Today it is one of the chichiest areas of Mexico City, with pricey urban mansions, including a few by Luís Barragan.

❸

THE PHOTOGRAPHER

"Frida is the most intelligent of my daughters. She is the most like me."
Guillermo Kahlo

Apparently it was Matilde who encouraged Guillermo to take up photography and set up a studio in Mexico City. Her father, also a photographer, lent them a camera to get started. Guillermo had an early break in 1904, getting a commission from State Secretary, José Limantour, to document Mexico's indigenous and Spanish architectural heritage. The photographs were intended for publications celebrating the 1910 centennial of Mexican Independence. The commission lasted from 1904 to 1908. Guillermo did a great job and was rewarded with the title of Official Photographer of Mexico's Cultural Patrimony. Frida learnt the art of photographic portraiture, including detailed finishing, from Guillermo. She was also absorbing the importance of image, not least knowing how to construct her own image to maximum effect. Frida had an amazingly hyperaware sense of, and talent for, this: a selfie queen before her time. She also had an acute instinct for celebrity.

WHO?
FRIDA'S PORTRAIT OF HER FATHER,
PAINTED IN 1952.

4

REWRITING HISTORY

"She was like a little bell from Oaxaca."
Frida Kahlo on her mother.

With her awareness of her public image, Frida was also prone to rewriting history, or exaggerating aspects of life to suit whatever she wished to project. Thus she claimed she was born in the year of the Mexican Revolution, in 1910. Her father, she later said, was from a Jewish family, a fact accepted unquestioningly by several biographers. In fact the Kahlos were from a long line of Protestant artisans. She always emphasized her mother's poor indigenous Indian roots, deliberately forgetting to mention that Matilde was the daughter of a Spanish general, although her grandfather, also a photographer (it would seem to have been rather a family trade), was of Indian descent. When Frida was born Matilde fell ill, so the child was suckled by an Indian wet-nurse. Frida was to make much of this later on: her indigenous Mexican heritage was acquired at the breast; nothing could be more authentic.

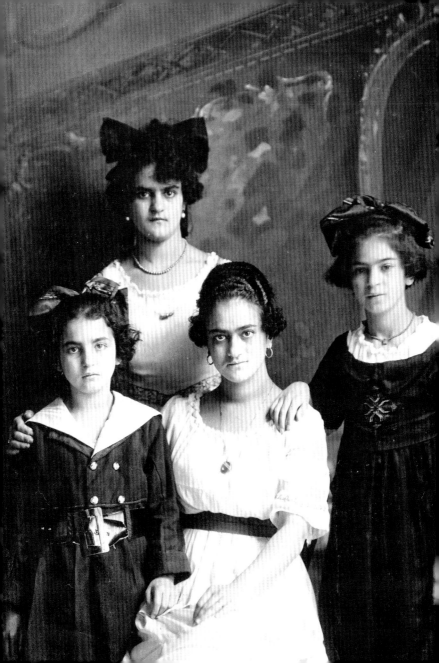

5

REVOLUTION

"I witnessed, with my own eyes, the battle between Zapata's peasants and the Carrancistas." Frida

The now forgotten Mexican Revolution of 1910, initially a middle class revolt against the Diaz dictatorship, turned into a complex civil war, lasting in all its violent twists and turns until 1920. Mexico City was the scene of much bloodshed, particularly during the 'Tragic Ten Days' of 1914. Frida saw herself as a child of revolutionary chaos, of the birth pangs of modern Mexico. She somewhat romantically claimed that she and the Revolution were born the same year – 1910 – but also recalled in her diaries seeing street battles between the rival armies of Zapatistas and Carrancistas: a memory a seven year old might recall, a four year old less so. The Revolution was in fact a disaster for the Kahlos. Guillermo had his photographic commissions thanks to the Diaz regime; in 1910 these all dried up. A decade of civil war was not conducive to business. The Kahlos mortgaged themselves to the hilt, sold their furniture, took in paying guests and scrimped just to get by.

WHERE?
MOUNTED ZAPATISTA REBEL COLUMN
ON THE OUTSKIRTS OF MEXICO CITY IN 1910.

6

POLIO

"We were quite cruel about her leg."
Aurora Reyes, childhood friend.

The extraordinarily feisty, but also poignant, life of Frida was defined by the inextricable intertwining of her art, her illnesses and her refusal to be beaten by the latter. It all started at the age of six, when she developed polio and was confined to her bed for nine months. Her right leg withered and then, when she was able to walk again, in funny little boots, and returned to school, she was relentlessly teased for her deformity. But Guillermo and Frida were fighters. He encouraged her to take up sports, not just swimming (at which she excelled), but the then very unladylike, boxing, wrestling and football. Frida became a bit of a tomboy, a toughy. But beneath it all she knew she was different, that fate had marked her in some way. Later, this gave her a detached perspective: she didn't have to accept conventions, mores, or gender-specific roles. Frida could make her own rules, outrage decency, cut to the core of her sexuality, use her inner strength to deal with pain. At root there may have been a deep-seated anger at the cards she'd been dealt; but Frida was too clever to let her anger turn her into a victim.

WHO?
FRIDA AS A YOUNG GIRL,
PHOTOGRAPHED BY GUILLERMO KAHLO.

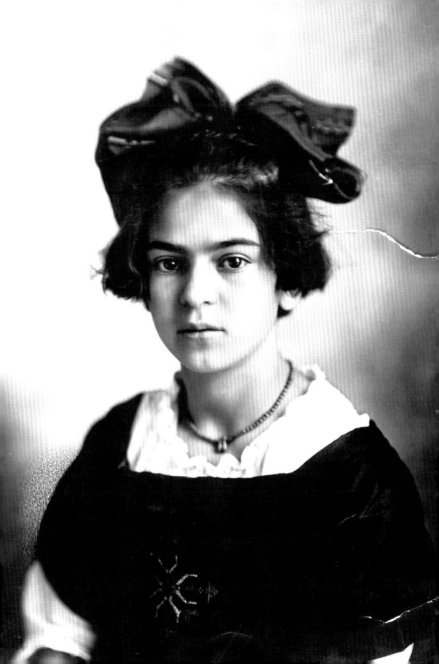

❼

LA PREPARATORIA

"Liberty, Order and Progress."
School motto

By most accounts, the Preparatoria was simply the best school in Mexico. Created as an integral part of the National University, right in the centre of town, Frida, pushed by Guillermo, did incredibly well to get in, one of 35 girls in a school of 2,000. She joined in 1922, aged 14, catching the trolley bus for the one hour journey to school. She cut an eccentric, slightly Germanic figure, in pleated skirt, silk stockings and a big black straw hat. There was a new spirit of confidence in the post-Revolution future sweeping the Preparatoria. Much of this was the result of the policies of a genius education minister, José Vasconcelos, later to be a patron of Diego Rivera. Frida's school mates sensed that they would be part of a future elite and formed into cliques, depending on their political or artistic inclinations. Frida joined the Cachuchas, the brainy but rebellious gang. They were voracious readers: Pushkin, Gogol, Tolstoy, Hegel, Kant, contemporary Mexican fiction. Clever, feisty, argumentative, independent, Frida was in her element.

WHERE?
THE MAIN COURTYARD OF THE PREPARATORIA,
MEXICO CITY CENTRE.

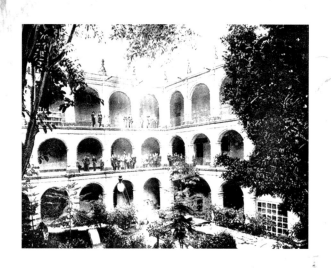

❽

MEETING RIVERA

"You'll see, fatso; now you pay me no attention, but one day I will have your child." Frida, to herself, about Diego.

In 1922 Diego Rivera, 36 years old, by now world-famous and comfortably fat, was commissioned by José Vasconcelos to paint a mural in the Preparatoria's Bolívar Amphitheatre. Dressed in his trademark baggy trousers and wearing a Stetson, he worked perched high on a scaffold, accompanied by his then mistress Lupe Marín or the stunning model (later photographed by Edward Weston) Nahui Olín. In her shameless, mischievous way, Frida would creep into the out-of-bounds auditorium to have a snoop, and to try to distract the 'heroic' great painter. One prank apparently involved her soaping the steps to the scaffold, so Diego would slip coming down. Rivera recounted in his autobiography how on another occasion she spent three hours watching him paint: "she had unusual dignity and self-assurance, and there was a strange fire in her eyes", he remembered. All this was a premonition. At the time Frida had started going out with one of her fellow members of Los Cachuchas, Alejandro Gómez Arias.

WHEN?
DIEGO, WITH HIS DAUGHTER (WITH LUPE) RUTH, AT THE TIME
HE PAINTED HIS MURAL AT THE PREPARATORIA.

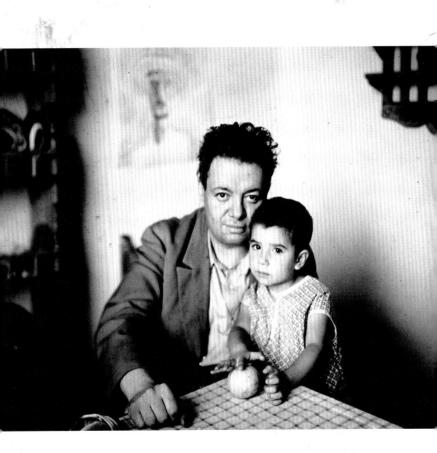

9

THE ACCIDENT

"The crash bounced us forward and a handrail pierced me the way a sword pierces a bull." Frida

September 17th, 1925 was a day as ordinary as any other. In the afternoon, Frida and her boyfriend Alejandro had caught a crowded bus from downtown Mexico City to Coyoacán. In front of the San Juan market, a heavy electric tram, whose brakes had just failed, was relentlessly heading towards Frida's bus. It hit the bus in the middle, pushing it, bending it in half, running over passengers in its wake, breaking the bus into hundreds of pieces. Several people were killed instantly. Frida's body was pierced by a handrail just above her pelvis, coming out through her vagina. She was swamped in blood. An ambulance took her to the Red Cross Hospital. Her injuries were so severe doctors doubted they could save her. The most significant damage was to her spinal column, broken in three places. But unbelievably, her surgeons somehow put her back together again and, on October 17th, she went home. But Frida's life had changed forever.

WHERE?
MEXICO CITY TRAMS, FROM THE 1920S.
IT WAS ONE OF THESE THAT CRASHED INTO
FRIDA'S BUS WITH DEVASTATING CONSEQUENCES.

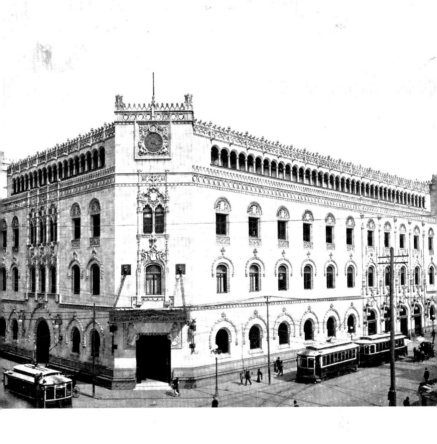

❿

AFTERMATH

"I paint myself because I am so often alone...I am the subject I know best." Frida

The crash had not just broken her spinal column in three places, but her pelvis in three places, her collarbone, her third and fourth ribs, caused 11 fractures on her leg, crushed her right foot and knocked her left shoulder out of joint. When she got home, Frida realised that she would have to spend months in bed, a depressing prospect as, being one hour out of Mexico City, it was unlikely she would get many visitors. She was also in great pain, and was being treated with chloroform, cocaine, and Sedol and, when misaligned vertebrae were diagnosed, was in and out of plaster casts. There were problems with Alejandro. He had discovered she had been unfaithful and was refusing to visit. As an entreaty not to drop her, Frida painted him her first self-portrait. It had its desired effect; Alejandro did return. More importantly Frida had discovered that one way of coping with her condition was to paint. She then stumbled on a gripping purpose for her art: to describe, searingly, viciously if necessary, what her body was going through.

WHERE?
FRIDA (MIDDLE IN A MAN'S SUIT) IN THE GADEN AT LA CASA
AZUL, SHOWING HER AMAZING ABILITY TO HIDE HER CONDITION.
GUILLERMO KAHLO TOOK THIS PICTURE IN 1926.
ON FRIDA'S RIGHT IS HER SISTER CRISTINA.

FRIDA IN MEXICO CITY

The core of the old Spanish city was Frida's stamping ground as a young schoolgirl and then. After she was active again after her accident, it was where Frida hung out as part of the cool set around Tina Modotti and Germán de Campo. It was here also that Diego had been commissioned to paint murals in the colonial buildings of the Palacio Nacional and the Ministry of Public Education, as well as at Frida's school, the Preparatoria.

Preparatoria School
Frida was one of 35 girls in a school of 2000. She was here aged 14, until the tram accident, when she was 18. Frida first came across Rivera when he was commissioned to paint a mural in the school auditorium.

Mercado de San Juan
It was in front of this market that Frida's bus was hit by an electric tram on 17th Sept, 1925. The accident would have a lasting impact on her life.

Red Cross Hospital
Frida was taken here after the accident. Her surgeons thought she wouldn't survive, but in the end managed to save her life.

Tina Modotti's Studio
Frida most probably met Rivera at one of Tina's famed demi-monde parties here, in 1928.

Ministry of Public Education
Rivera was painting murals here in 1928, when Frida went to seek his opinions on her early work. A couple of weeks later they began their affair.

Palacio Nacional
Frida would regularly bring Diego a traditional campesina lunch basket whilst he worked on murals here in 1929.

Paseo de la Reforma
Frida and Diego's first home, was at number 104.

Palacio de Bellas Artes
Mexico City's fabulous fine arts museum was frequented by Frida and Diego.

MEETING DIEGO

The sheer injustice and bad luck to suffer the effects of polio as a child, followed by the terrible accident which nearly killed her aged 18, was to bring out Frida's inner strength and fierce intelligence, she discovered that through art she could find not just a coping mechanism, but a form of expression which would cut to the core of anyone who viewed her images. Frida was determined that far from quenching her spirit, her suffering would become an integral part of it. Frida knew she was charming, engaging and, if not vapidly good looking, very alluring. The accident would certainly not squash her sexuality; she would make it a part of her. She was taking the Nietszchean dictum that what doesn't kill you makes you stronger very literally. She would get more from life, be funnier, more challenging, more brazen, cheekier, sexier. Through it all would run the thread of suffering that she revealed so clearly, searingly and without artifice. But a heroic sufferer or victim she wasn't. She was simply painting her reality. The next dramatic event in her life – properly meeting and marrying the much older Diego Rivera – was to prove how effective her coping stratagem was. She had found and fallen in love with her 'frog prince', and he was enthralled with her. Frida's life was transformed from one lived in provincial Mexico City, with an uncertain future, not least financially, to one of glamorous international commissions and travel with the world's most successful painter. Frida, it seemed, had an instinctive knack for making her life extraordinary.

1

TINA MODOTTI'S PARTIES

"Tina Modotti...was the 'It Girl' of the Mexican avant-garde." The Guardian

Despite having to constantly wear orthopaedic corsets, Frida began to lead a more or less normal life. She could now revisit her old haunts in Mexico City. Her contemporaries at the Preparatoria had gone on to the University. Frida did not resume her studies, but she did resume her friendships, intrigues and search for fun in a city alive with demi-monde ideas, in a similar vein to Paris and Berlin in the '20s. Through her friends, Frida met Tina Modotti, the nude model, lover and assistant of the photographer, Edward Weston. Born in Italy and based in San Francisco, Tina was the subject of Weston's most stunning nude studies; she was also learning the art of photography in the portrait studio he had opened in Mexico City. Tina used to organise weekly bohemian soirées for the city's artists and political activists. It was, according to some accounts, at one of these that Frida bumped into Rivera again. He had separated from his second wife, Lupe Marín, apparently following his affair with Modotti (whilst she posed for the nudes in his Ministry of Agriculture murals). The hugely fat Rivera was already one of the world's most renowned artists. Something about him made him very attractive to a string of very good-looking women.

❷

THE MINISTRY OF EDUCATION

"Look I have not come to flirt...I've come to show you my painting." Frida to Diego Rivera.

Diego Rivera had returned from Europe to do a mural at the Ministry of Education. Frida, never shy, had decided to seek his opinion on her first works and turned up unannounced. He clambered down from his scaffold and had a look. According to his own account, Diego was impressed: "The canvas had an unusual energy and expressiveness...a vital sensuality, together with a merciless but sensitive power of observation." Frida, who had recently split with Alejandro, took the encouragement, then brazenly invited him to her house in Coyoacán to see more or her work; she knew Diego's reputation and was willing him on. It was then that it dawned on Diego that she was the girl who had teased him so many years earlier. He was intrigued and went; they kissed for the first time a few days later. After his mural was finished, Diego, now completely enamoured, began courting Frida in earnest; "I did not know it then, but she had already become the most important thing in my life."

WHERE?
DIEGO RIVERA, PHOTOGRAPHED SHORTLY
AFTER FRIDA FIRST MET HIM

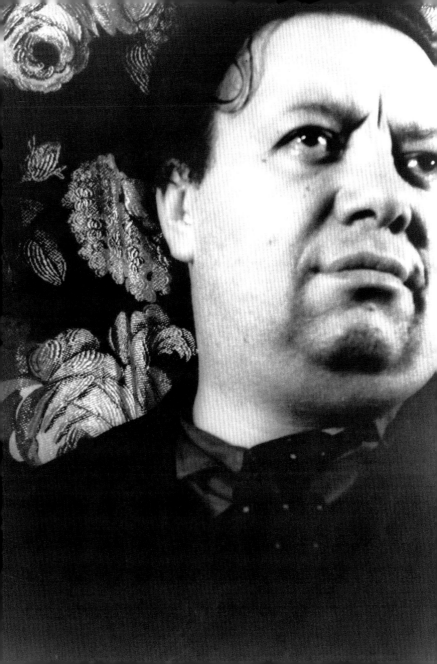

❸

"*I am a daughter of the Revolution.*"
Frida

Frida had joined the Young Communist League, like a number in her circle, in 1927. In 1928, Mexico was in ferment once more, with a quasi-dictatorial government in the ascendant, threatening amongst other things the autonomy of the Univesity of Mexico. Student politics merged with radical left and Communist elements. The leader of student opposition, Germán de Campo, was a good friend of Frida's. He introduced Frida to Cuban Communist exile Julio Antonio Mella. He was also at the time Tina Modotti's lover. Frida joined the party proper in 1928. She started wearing red or black shirts, and sported hammer and sickle badges. Her revolutionary credentials also appealed to Rivera, who too was heavily involved with the Party; love, intrigue, sex, the political and artistic fight for the 'true' Mexico, all melded into one heady, intense and dangerous brcw: Mella was assassinated by right-wing activists in 1929.

WHERE?
COMMUNIST IDEALISM, REFLECTED IN DIEGO
RIVERA'S MURAL FRUITION: THE FECUND EARTH,
AT THE MINISTRY OF AGRICULTURE, 1927,
THE YEAR FRIDA MET RIVERA AGAIN.

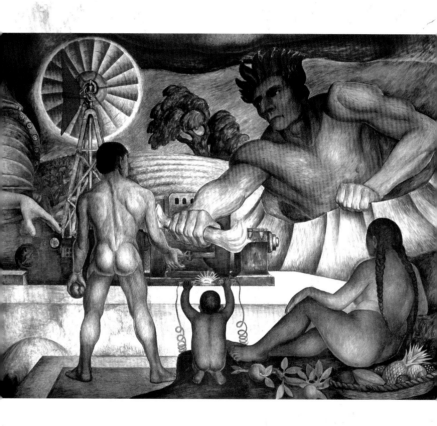

4

CASA DE CORTÉS

"My daughter...all her life she will be sick; she is intelligent but not pretty...if you wish to marry her, you have my permission."
Guillermo Kahlo

Guillermo Kahlo's appraisal of his daughter was teasingly disingenuous. Surely he clocked that 22 year-old Frida exuded a very direct sexuality and allure, married to a sharp and original mind. He did understand, perhaps as a result of the financial challenges he had faced, that the wealth of Rivera would offer his daughter protection, not least when it came to future medical bills. Matilde, however, was totally opposed to Frida marrying a much older (42), twice divorced Communist – a self-confessed 'prince-toad' – even if he was rich. She didn't turn up for the modest civil ceremony. Frida dressed in peasant clothes. A party was held later on the roof of Tina Modotti's house, amongst clothes lines hung with underwear. Diego got really drunk on tequila and he and Frida had a fight. Lupe Marín also came and made a scene. Frida and Diego's somewhat chaotic and intense marriage was underway.

WHERE?
CASA DE CORTÉS (EFFECTIVELY THE TOWN HALL),
PLAZA HIDALGO,
COYOACÁN.
FRIDA AND DIEGO WERE MARRIED HERE.

5

LA CAMPESINA

"She subordinated her waywardness to his; otherwise life with Diego would have been impossible." Bertram Wolfe, Rivera biographer.

In the first few months of their marriage, Diego was frantically busy with commissions: murals for the Ministries of Education and Health, as well as scenery for the ballet *HP* and then his epic works for the National Palace. And for those first few months, Frida did little of her own work, focussing on Diego entirely. She would often join him on the scaffold to keep him company. Lupe Marín, strangely, became an ally, advising her on the sort of food Diego liked and sharing recipes. Frida would prep his lunch in a basket, decorated with flowers, in the manner of Mexican *campesinas* (peasant women) feeding their husbands toiling in the fields. She was happy to embrace tradition and traditional roles, in typically Tehuana style. This was independent Frida in typically contradictory mode. Not many campesinas had their own centre of energy, their own upper-middle class, urban, bohemian circle of friends, or their own artistic journeys. Frida was appropriating elements of *Mexicanidad* and shaping them to fit her emerging, very studied self-image.

WHERE?
DIEGO RIVERA'S MURALS AT THE NATIONAL PALACE:
CLASS STRUGGLE AND *THE HISTORY OF MEXICO.*

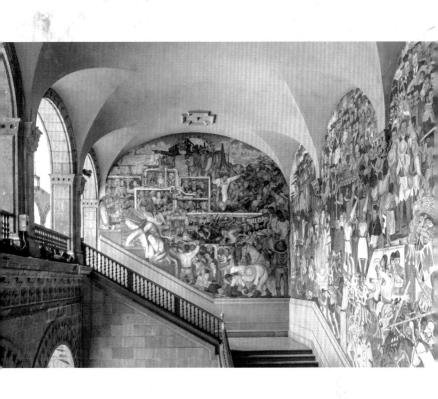

❻

CUERNAVACA

"I suffered two grave accidents in my life. One....a streetcar...the other...Diego."
Frida

It was the US ambassador to Mexico, Dwight W. Morrow, who commissioned Diego to paint a mural for the Cortés Palace in Cuernavaca. He also gave the Riveras the use of his splendid rambling house there whilst the commission was undertaken. Here Frida and Diego had a sort of honeymoon, but one where Diego was working hard all day and drinking hard with their many visitors at night. Whilst at Cuernavaca Frida fell pregnant, but after three months had to have an abortion as the foetus's head was developing in the wrong position. And whilst at Cuernavaca, Diego also had an affair with his assistant, Ione Robinson. Did Frida care? Did she pretend not to care? Was she amused rather than hurt? Did she accept it in the spirit of embracing unconventionality? There were many intertwined emotions, but the strongest was despair at the prospect of probably never being able to have a child.

WHERE?
TYPICAL HOUSE IN CUERNAVACA.

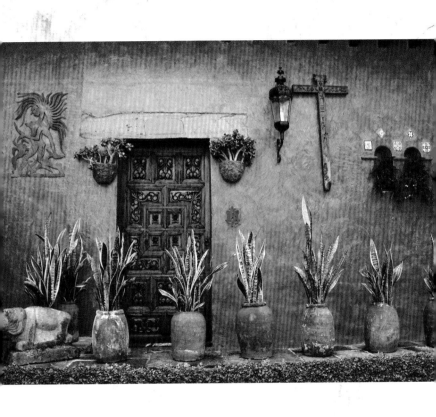

TEHUANA

"At another time, I dressed like a boy... but I put on a Tehuana costume when I go to see Diego." Frida

Whilst at Cuernavaca, Frida began to express herself through the exotic costumes of Tehuana women. Frida was further developing peasant *Mexicanidad* as an integral part of her persona. When she mixed Spanish, Tehuana and other Indian styles, with her signature braided and beaded hair, and heavy pre-Columbian jewellery, she began, in stages, to define the style for which she is still universally recognised. Even if we can't precisely describe Frida's style in words, it is unmistakable when we see it. She, of course, didn't know it then, but this was to be one of her enduring achievements, allowing her to eclipse her husband with an image that now almost appears immortal. And it pleased and served Diego well. Whilst his murals depicted the lives of Mexican peasants, his wife showed how their costumes could be reinvented into a style charged with intense energy, originality and magnetism.

WHEN?
FRIDA IN AN EARLY MANIFESTATION OF HER TEHUANA STYLE. AS TIME WENT ON, HER LOOK WOULD BECOME MORE FORCEFUL, MORE DIRECTIONAL.

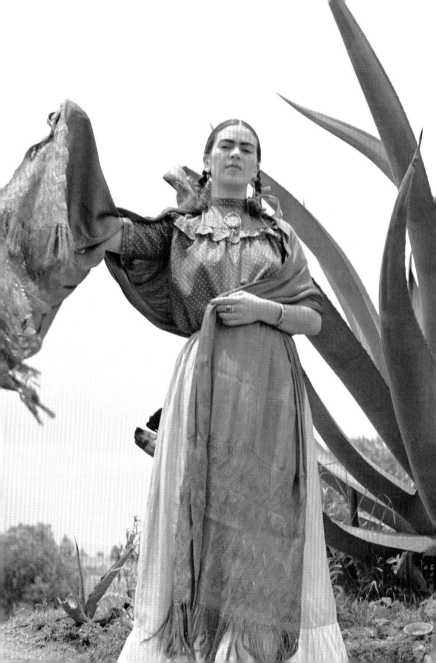

AMERICA

Surprisingly for two avowed Communists, Frida and Diego were to spend four years in the United States. Mega capitalists were drawn to Diego like bees to nectar, showering him with commissions. It wasn't just that his art was brilliant and heroic, but it also served to display his patrons' ostensible liberalism and broad-mindedness. They were using Diego, just as he was using them to push a socialist message – Diego saw himself as a spy in the enemy's camp. In 1929 he had effectively been pushed out of the Communist Party in Mexico by Stalinists, appalled at his accepting commissions from the government; Frida then resigned. But Diego stuck to his Marxist principles, which served only to attract a commission from the San Francisco Stock Exchange and later from Henry Ford in Detroit. The contradiction only came to a head in New York during Diego's creation of murals for the Rockefellers. For Frida this was an enthralling time at first. It was in the US that she really honed the Tehuana style which makes her instantly recognisable today. She had much time just to explore all facets of American culture. Her painting really began in earnest. She made life-long friendships in the US, and also enjoyed provoking the more tedious wives of Diego's patrons. But it was also in the US that she was to suffer the anguish of more personal tragedy. Ultimately Frida was not impressed by the States. She longed to be back in Mexico City.

SAN FRANCISCO

"I don't really like the gringo people...they have faces like unbaked rolls." Frida

When Frida and Diego arrived in San Francisco in November 1930 they had an instant entrée into the high-end art crowd in the city. They first moved into the sculptor Ralph Stackpole's studio on Montgomery Street in the old artists' quarter. The very connected artists, Arnold and Lucille Blanche, lived two floors down. Frida and Diego had ample time to explore the usual sites. Diego also needed inspiration for his murals, so they also went on visits to gold mines, oil derricks and to the back country. Frida loved making fun of what she termed 'Gringoland', particularly at the absurd pretentions of the locals. During extended periods when Diego was working she would wander the streets dressed in her Mexican costume, attracting much attention. She particularly loved shopping for silks in Chinatown. Shortly after arriving, she also met world-famous photographers, Ansel Adams and Edward Weston, Tina Modotti's old maestro and lover.

WHERE?
VIEW OF SAN FRANCISCO FROM THE BAY,
TAKEN CIRCA 1930; HAND COLOURED
CONTEMPORARY PHOTOGRAPH.

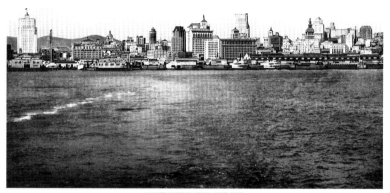

SAN FRANCISCO FROM THE BAY.

❷

DR· ELOESSER

"Of my friends you are the one I love the most." Frida to Dr. Eloesser.

If Diego was amazing at opening doors, Frida was brilliant at walking through and forming life-long friendships. In San Francisco she met one of the most important figures in her life. Dr. Leo Eloesser, who already knew Diego Rivera, was a Professor of Surgery at Stanford Medical School, as well as the leading surgeon at San Francisco General Hospital. A true original, he loved to sail his 32-ft sloop at midnight and spend the night out at Red Rock Island, before heading back to work in the city in the morning. Frida first consulted him in 1930, and would continue to do so for the rest of her life – long letters describing her various conditions and asking his advice. She trusted him above all other doctors and he in return never charged her, although he gladly accepted her *Portrait of Dr Leo Eloesser*, which included a sailboat called *Los Tres Amigos*.

WHO?
FRIDA'S PORTRAIT OF DR ELOESSER,
PICTURED WITH *LOS TRES AMIGOS*.

❸

ATHERTON

"I spend most of my time painting."
Frida to Isabel Campos.

In 1931 Diego and Frida spent six idyllic weeks at the home of Mrs Sigmund Stern, just outside San Francisco, in Atherton. They had already acquired a talent, extraordinary for such passionate Marxists, for hobnobbing with the super-wealthy. The Sterns were part heirs to the Levi-Strauss fortune (valued, in today's terms, at $169 billion when the founder died in 1902) and prominent local patrons of the arts, in particular of Ansel Adams. But the significance of Atherton is that here Frida painted her first semi-surrealist work *Luther Burbank*. It was away from Mexico, and away from the hubbub of San Francisco, that Frida started to really find her trajectory. When she returned to San Francisco with Diego, she was ready to create one of her best-known paintings, the 'wedding portrait' *Frida and Diego Rivera.*

WHERE?
A TYPICAL MANSION IN ATHERTON,
'THE USA'S MOST EXPENSIVE ZIP CODE'.

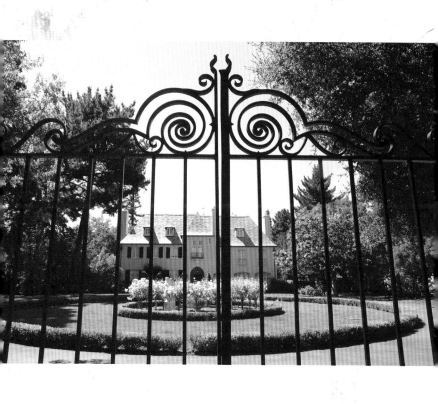

4

NEW YORK

"It is terrifying to see the rich having parties day and night while thousands... are dying of hunger." Frida

It was Frances Flynn Payne, art advisor to the Rockefellers, who suggested Diego be given a retrospective at the fledgling Museum of Modern Art in NYC. The Riveras had briefly returned to Mexico – Frida had gone on one month ahead, where she met Hungarian photographer Nickolas Muray and began their extended affair – before sailing to New York aboard the *Morro Castle*. From the moment they arrived, they were treated as celebrities, with Diego interviewed for the *Herald Tribune*, and invitations to parties hosted by the cream of Manhattan society. Diego relished it all, Frida perhaps less so. But New York loved her. Everyone commented on her extraordinary mono-brow, her jewellery, her Tehuana style, and her sometimes very direct speech. Rivera's opening at MOMA was a major social event. The show itself was a popular and critical success. Whilst Frida expressed her dismay at the extreme inequality she saw privately, she didn't comment in public.

WHERE?
THE WALDORF-ASTORIA HOTEL, SYMBOL OF NEW YORK
EXCESS, IN MID-TOWN MANHATTAN, IN 1931. MEANWHILE,
IN THE LOWER EAST SIDE, IT WAS A CASE OF THE POST-
CRASH UNEMPLOYED QUEUEING AT SOUP KITCHENS.

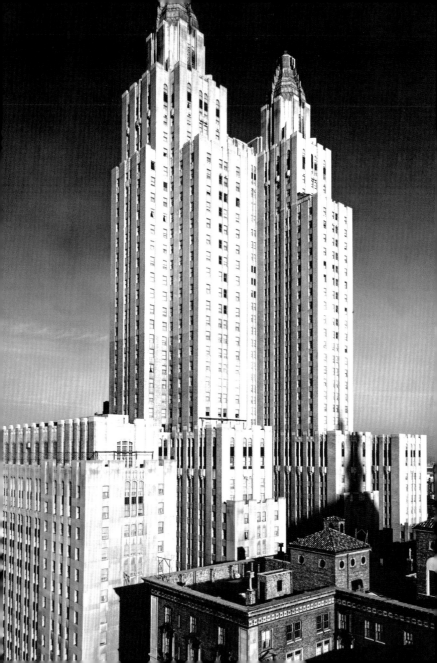

❺

THE BARBIZON

"High society here turns me off."
Frida to Dr. Eloesser.

Whilst in New York, the Riveras took an apartment at the Barbizon-Plaza, then the fashionable place for wealthy artists to stay, close to Central Park and five minutes from MOMA. It had opened in 1930 and billed itself as a 'music-art' residence, with studios for artists and exhibition and performance spaces. Frida said she hated it, particularly the snooty bellhops, who treated her with disdain, she thought because she came across as 'not wealthy' (but more likely because she did not tip the way they expected). But her days in Manhattan were fun. On the many days Diego was busy, she hung out with Lucienne Bloch, had long lunches and went to the movies. According to Bloch, Frida's favourites were Laurel and Hardy and the Marx Brothers. She also enjoyed horror movies, and went to see *Frankenstein* twice.

WHERE?
FRIDA AND DIEGO IN THEIR APARTMENT AT THE
BARBIZON-PLAZA,
6TH AVE AND CENTRAL PARK SOUTH,
MANHATTAN.

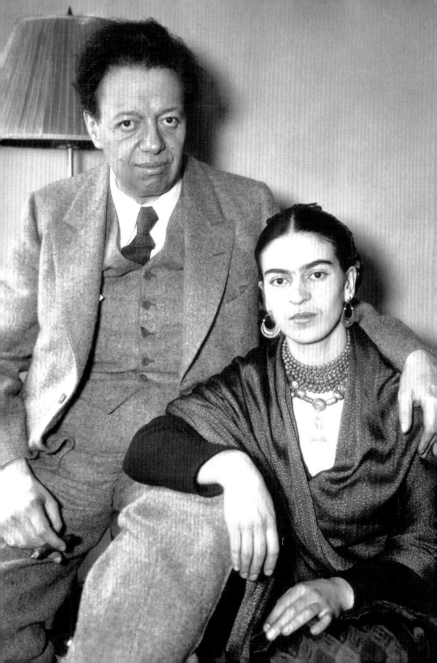

6

DETROIT

"Henry Ford made the work of the Socialist state possible." Diego Rivera

The next temple of capitalism to lure Rivera was Motor City – then in its glitzy, art deco prime. Rivera had been approached in San Francisco by the Detroit Institute of Arts – headed by Edsel Ford – to paint a mural celebrating Detroit industry and the Ford Motor Company in particular. The commission was worth $10,000 (roughly $175,000 today – rather a bargain for Ford). In April 1932 Frida and Diego travelled by train and were met by a large party on their arrival. Frida made an instant impression, dressed in a black silk brocade dress, amber and jadeite necklaces, green shawl and high heeled slippers. Diego introduced her using her second name 'Carmen' – the name 'Frida' now had unfortunate Nazi overtones, given the anti-Hitler political climate. Frida was asked slightly patronisingly by the press whether she too was a painter, to which she replied ironically: "Yes, the greatest in the world."

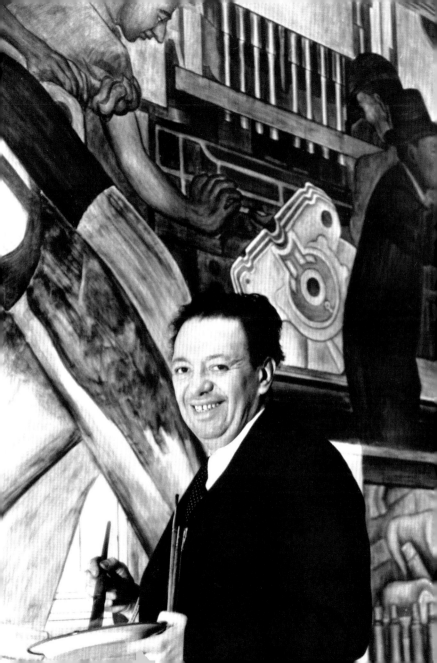

GROSSE POINTE

"Mr Ford, are you Jewish?"
**Frida, loudly, to the well-known anti-Semite,
Henry Ford, at a society dinner party.**

Frida spent some of her time in Detroit touring car factories with Diego, in particular the River Rouge Ford complex. He loved the machinery, the assembly lines, the labs, the idea of man and machine working as one. Frida was happy he was getting so much material, but enjoyed the social whirl a lot less than she had in New York. The uber-wealthy but very dull industrialists' wives, who invited Frida to tea and dinner at their Grosse Pointe mansions, did not get her eccentricities or her style. She retaliated by behaving outrageously, for instance, asking old matrons "what does the expression 'I shit on you' mean?", or declaring her Communism in the most right-wing homes. As in New York, Diego was unabashed in his embrace of the capitalists, believing that his murals, which they paid for, would serve to publicise Socialist virtues and the heroism of the common man. Frida didn't paint whilst here, but did, on May 26th, discover that she was once again pregnant.

8

THE HENRY FORD HOSPITAL

"I do not think Diego would be very interested in having a child." Frida

On discovering her pregnancy, Frida's first instinct was to try and abort. She tried quinine and castor oil. Neither worked, so she decided, despite feeling weak and scared that she might not survive, to have the baby, even if it meant spending the next seven months in Detroit. But on July 4th, Frida had a miscarriage, losing huge amounts of blood. Diego in a panic called an ambulance and she was rushed to the Henry Ford Hospital. Here she would spend 13 very grim days, still losing blood, getting weaker and weaker, and more terrified than ever that she would never have children. Five days after she was admitted, Frida felt compelled to draw a self-portrait, then a foetus and then further drawings using the automatism technique invented by the Surrealists. When she returned to their apartment she created one of her most memorable early works, *Henry Ford Hospital*. From her suffering and loss she had a creative breakthrough.

WHERE?
FRIDA HAD AN AMAZING ABILITY TO BOUNCE BACK.
THIS VERY SELF-POSESSED PORTRAIT, BY LUCIENNE BLOCH,
WAS TAKEN SIX MONTHS AFTER HER MISCARRIAGE.

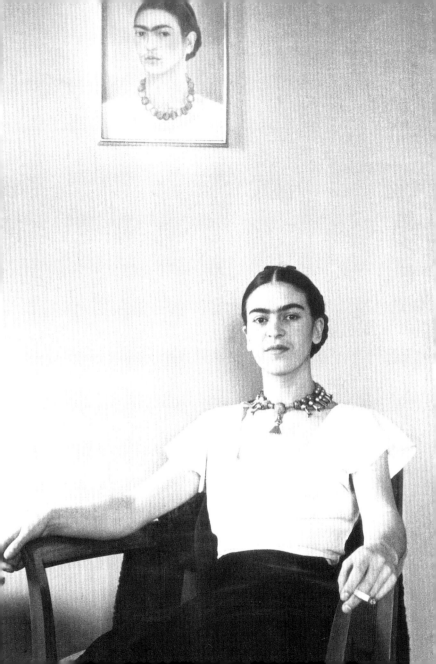

NEW YORK 2

"Frida went through dime stores like a tornado." Lucienne Bloch

Frida's Detroit sojourn was interrupted by news from home: her mother was seriously ill. She returned to Mexico, but two weeks after her arrival, on September 15th, 1932, Matilde died. In the midst of her grief Frida painted the searing, almost unbearable *My Birth*, showing a shrouded figure giving birth to a dead child; it was Frida's medical conditions, her mother's death and her miscarriage fused into one of the most visceral images ever created. It was a huge relief when she and Diego arrived in a bitterly cold New York in March 1933. Frida loved being back in the Big Apple. The wealthy crowd here were interesting, fun, open-minded. She loved the shops, the cinemas – she especially loved the *Tarzan* films showing in Brooklyn. She and Diego had again taken up residence in the Barbizon and Frida spent a lot of time at home. Despite this, she barely did any painting: the eight and a half months she spent in New York produced only one unfinished picture.

WHERE?
FRIDA AND DIEGO BACK IN THEIR APARTMENT
AT THE BARBIZON-PLAZA,
MANHATTAN,
NEW YORK.

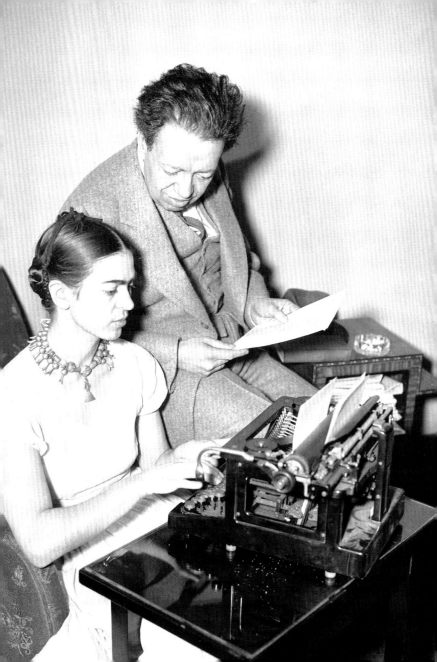

ROCKEFELLER CENTER

"Mrs Rockefeller was very nice to us always...very interested in radical ideas."
Frida

The paradox of Rivera, the Marxist, painting murals at the temples of the ultra-capitalists, finally came to a head in New York. Frida was completely wrapped up in the ensuing fracas. Rockefeller had commissioned a mural for his Rockefeller Center on Fifth Avenue. Rivera chose to split the mural, with Wall Street fat cats, downtrodden workers and war depicted on the left, and a Marxist utopia of a beaming proletariat on the right. It caused a storm, exacerbated by Diego then adding Lenin as a workers' leader to the composition. When Rockefeller, against his will, cancelled the contract – he did pay Rivera's fee in full – demonstrations and pickets outside Rockefeller Center ensued, with mounted police holding angry workers back. Frida joined the latter in full Mexican dress. The story was front page news. In the following days, Rivera gave lectures extolling Socialism, always supported by Frida in costume, including one at Columbia University resulting in five hours of fights, with the university president burned in effigy.

WHERE?
DIEGO ON THE SCAFFOLD AT ROCKEFELLER CENTER,
SHORTLY BEFORE THE LENIN CONTROVERSY BROKE.

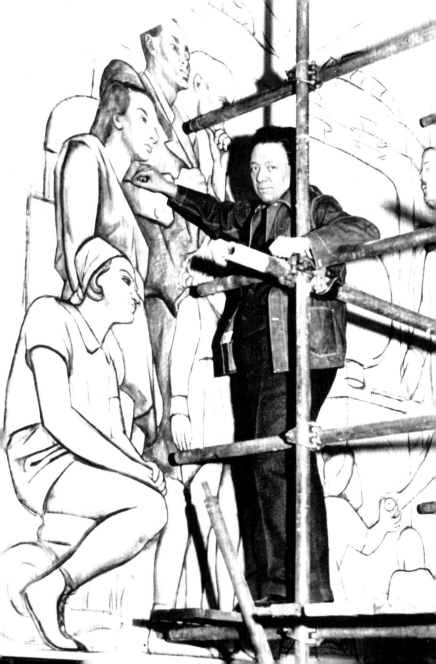

⑪

EIGHTH STREET

"I don't like the gringos...their disgusting puritanism, their protestant sermons, their endless pretensions." Frida

The row over the Rockefeller murals demoralised Frida as well as Diego. He soon picked himself up by starting a new commission of the history of the USA for the New Workers School, from a left-wing perspective. The Riveras moved from the Barbizon, first to Greenwich Village and then to Eighth Street. Frida held open house in the evening. Here one could bump into some wealthy socialite, or a labourer helping Diego with his scaffolds; the Riveras made no class distinctions. But then Rivera started an affair with Louise Nevelson, a divorcee admirer in the same building. He would disappear with her for days. Frida was despondent but accepting. Her foot was starting to give her trouble. She would spend days in the bath resting it. She, unlike Diego, was fed up with the US and wanted to get back to Mexico. Finally, in December, she won the argument and on the 20th they boarded the *Oriente* liner for Veracruz.

WHERE?
FRIDA AND DIEGO IN NEW YORK,
SHORTLY AFTER THE
ROCKEFELLER DEBACLE.

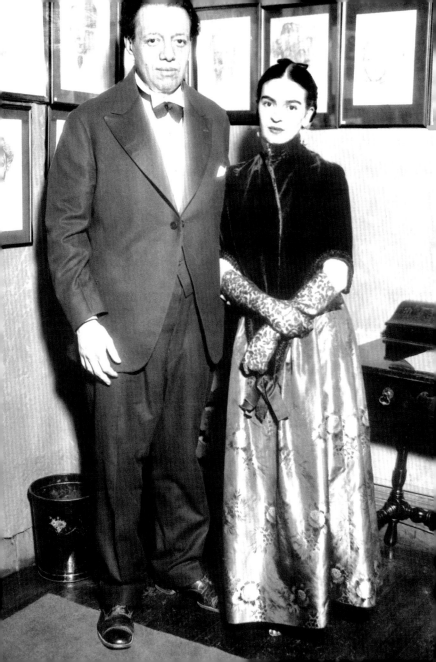

FRIDA IN THE USA

US clients, including the ultra-capitalist Henry Ford and Nelson Rockefeller, loved the work of the blatantly Marxist Diego Rivera. One year after their marriage, Frida and Diego were off to the States so he could fulfill his commissions. It was in the US that Frida first started painting seriously, but for all that she never really liked what she called 'Gringolandia'. In the face of many protestations from Diego, who loved the US, she insisted they return home at the end of 1933.

San Francisco
Frida and Diego arrived on 10th November, 1930. Diego had commissions for the San Francisco Stock Exchange Lunch Club and the California School of Fine Arts.

Atherton
Frida and Diego were offered the use of the Stern home in smart Atherton. They left San Francisco in mid-February 1931 and spent 6 weeks here. Diego painted a mural in the dining room, whilst Frida painted a breakthrough work, *Luther Burbank*, here.

Mexico City
May-November 1931. Frida flew back to Mexico City, with Diego following her in June. Whilst in Mexico City, work started on the Linked Studio House.

New York – first trip
Frida and Diego sailed into New York from Veracruz on the liner *Morro Castle*. Diego was here for his retrospective show at MOMA.

Philadelphia
On March 31st, 1932. Frida and Diego travelled by train to Philadelphia. They spent three weeks here.

Detroit – first trip
April 20th 1932. Frida and Diego travelled by train to Detroit. Diego undertook murals for the Ford Motor Co. Frida had a miscarriage in July.

Mexico City
September 1932. Frida returned to Mexico City as her mother was seriously ill. Matilde Kahlo died on 15th September, aged 56.

Detroit - second trip.
In October 1932 Frida rejoined Diego in Detroit.

New York - second trip
In March 1933, Frida and Diego arrived in New York for Diego's prestigious Rockefeller commission. The work, featuring a portrait of Lenin leading heroic workers into a utopian socialist future, caused a storm and Diego's mural was cancelled and later destroyed. Notwithstanding this, Diego wanted to stay in the US. Frida had other ideas.

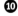

Mexico City
Frida and Diego returned on December 20th, 1933, to take up residence in the Linked Studio House, which had just been finished.

RETURN TO MEXICO

Frida had pressed Diego for a return to Mexico City. She didn't, at root, like the US, and she was probably bored of her status there of just being 'Diego Rivera's comely wife'. Whilst in the States, construction of the linked studio houses in San Ángel, the Linked House had proceeded apace and they were ready to move in. But Diego was not happy at leaving the energy of the US and the relevance of his art there: he was convinced, following the Marx analysis, that the Socialist revolution would first occur in a heavily industrialised society. He also missed, said Frida, the adulation of his patrons and the friendliness of people; in Mexico, she said "people always react to his work with obscenities and dirty tricks....he has only to arrive and they start attacking him in the newspapers...they are so envious of him." But Mexico was not to involve the domestic bliss that Frida envisaged. Within two years Frida would be living alone, although still in close contact with Diego.

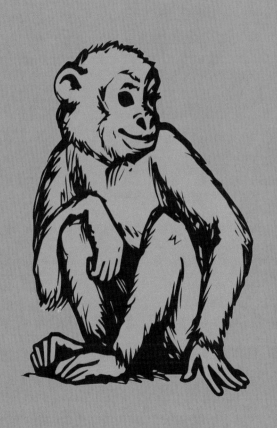

1

SAN ÁNGEL

"The situation with Diego is worse every day." Frida, letter to Dr, Eloesser.

Diego and Frida had been discussing building a house in Mexico City
for a while. The money Diego made in California made it possible.
They hired Juan O'Gorman, a follower of Le Corbusier, to come up
with a design with 'his' and 'hers' wings. The result was a triumph of
modernism, in sharp contrast to the rest of the neighbourhood. In effect
two houses linked by a bridge, Diego's was the larger red side, Frida's
the smaller blue one. Each had a studio on the top floor: Diego's a big
space for public events and sales, Frida's combined with her bedroom.
It should have been a great time, doing the two houses up, but neither
Frida nor Diego was happy. Diego missed the US and felt uninspired
and fed up. Frida then discovered that he had started an affair with, of
all people, her younger sister, Cristina. Betrayed twice over, she cut
her hair short, gave up wearing her Tehuana costumes, and painted the
gruesome *A Few Little Nips*, based on a press story about a man who
had murdered his girlfriend, by stabbing her 20 times over.

WHERE?
THE 'LINKED HOUSE' IN SAN ÁNGEL,
SOUTH-WEST MEXICO CITY.

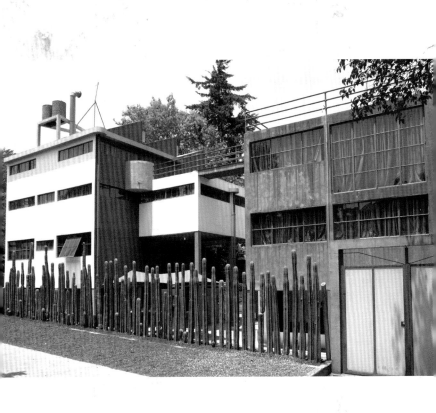

❷

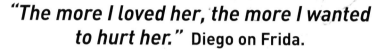

HOSPITAL AGAIN

"The more I loved her, the more I wanted to hurt her." Diego on Frida.

1934 was not a great year. Frida was in hospital three times. The first was to have her appendix removed, the second for an abortion after another three months pregnancy, and the third for recurring problems with her foot. Diego, who had been losing a lot of weight, was also feeling ill, despondent, with glandular disorders. To make matters worse, her doctors told Frida she should refrain from sex for a few months. The Cristina situation continued to cause Frida great anguish. She started blaming herself as a way of coping with it: "I am the one who should compromise if I want him to be happy", she stated. Diego however was getting back to work on his *Modern Mexico* mural in the National Palace; to add to his mental cruelty, the centre of the composition featured Cristina's very dainty feet in high-heeled sandals. For Frida, who had recently had an operation on her troublesome foot, this was hard to bear.

WHAT?
THREE OF FRIDA'S MANY SPINE-SUPPORTING CORSETS.
NONE REALLY WORKED.

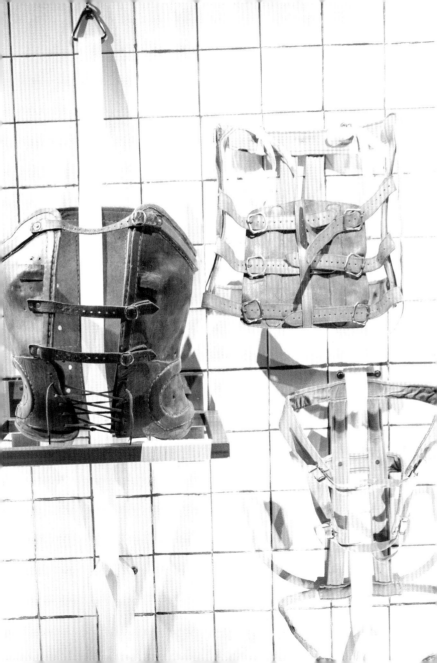

❸

AVENIDA INSURGENTES

"All these liaisons...only represent flirtations...at bottom you and I love each other dearly." Frida, letter to Diego.

It's tragically ironic that, having constructed the wonderful house with its independent wings, the state of Frida and Diego's relationship meant that she felt she had to move out. Frida bought a bachelorette apartment in the middle of the city. Simultaneously Diego was paying for another flat, in fashionable Florencia Street, for Cristina. But Frida and Diego kept seeing each other. He kept clothes in her apartment, she in his house. He bought her and Cristina similar furniture. She later forgave Cristina. But an impulse dash to New York in July, 1935, in a private plane with a pilot she had met at a dinner given by Diego, showed that she was still in turmoil. Being in New York served to make up her mind. Frida would put up with Diego's ways and would see her marriage, as she put it, as one of "of mutual independence."

WHAT?
FRIDA, IN INDEPENDENT MOOD, PHOTOGRAPHED AT
HOME.

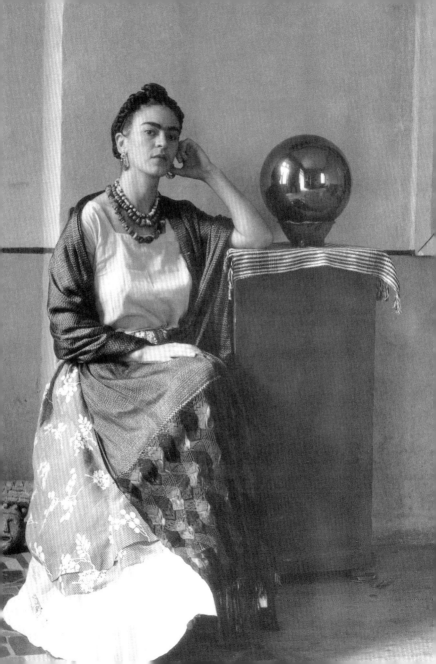

4

SAN ÁNGEL 2

"Diego considered Frida's lesbian affairs a sort of safety valve."
Jean van Heijenoort

After New York, Frida moved back into the linked house in San Ángel. It was comfortable and Frida could tell her servant to deny Diego access. She became the money-manager of the Rivera income, together with their accountant and friend, Alberto Misrachi. Frida and Diego often breakfasted together, in her side of the house, before going to their respective studios, or in Diego's case, often taking foreign female tourists on 'sketching' tours to the countryside outside the city. Frida became the queen of a glittering bohemian and artistic crowd, both Mexican and international, who loved to congregate at the Riveras'. It was at this time that she acquired her cheeky spider monkey, who would leap amongst her guests. Frida had found a new groove and she started to explore sexual adventures outside the marriage, with both men and women, as a way of balancing Diego's philandering. She also forgave her sister Cristina, treating her increasingly as her confidante.

WHERE?
FRIDA ON THE DECK OF HER HALF
OF THE LINKED HOUSE,
SAN ÁNGEL,
MEXICO CITY.

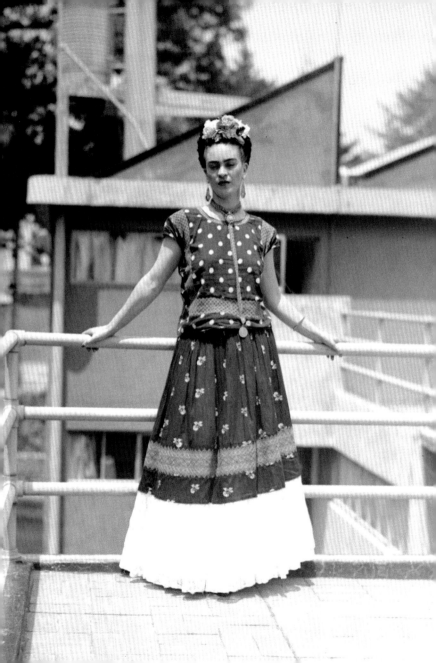

5

LA CASA AZUL 2

"We were indebted to Diego more than anyone for our liberation from captivity in Norway." Trotsky

Diego Rivera had been expelled by the pro-Stalin Communist Party in Mexico in 1930, and was constantly mocked by the Party for hob-nobbing with capitalists. When Trotsky was exiled by Stalin from Russia in 1929, Diego declared himself a Trotskyite. Trotsky spent nine years in exile, pushed from country to country, ending up in Oslo, before Mexico, thanks to Diego's friendship and influence with President Cardenas, offered him asylum. Diego was in hospital when Trotsky and his wife Natalia arrived, so Frida went as his representative. The Trotskys, who knew they were in mortal danger from Stalin's agents, ended up living in the easily defended Casa Azul in Coyoacán – Cristina and Guillermo, Frida's dad, moved out. Diego paid for heightened security, including the purchase of the house next door. The Riveras and the Trotskys became close friends. Frida rather admired the tall, heroic Russian who, like Diego, loved women; she began planning her retaliation for Diego's affair with Cristina.

WHERE?
THE ENCLOSED GARDEN AT THE BLUE HOUSE MADE IT
AN EASILY DEFENDED REFUGE FOR THE TROTSKYS.

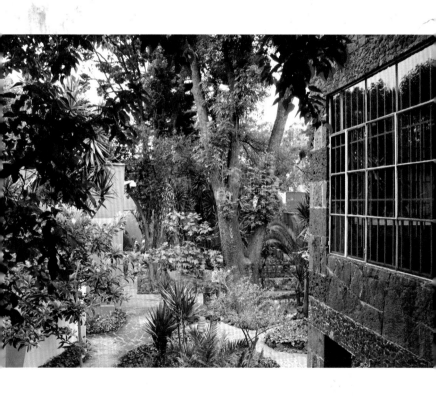

6

TROTSKY

"You admire this man, don't you?"
Guillermo to Frida, about Trotsky.

It was fairly straightforward for Frida to seduce Trotsky. He was 58, Natalia, his long-suffering wife of thirty years, 55, and Frida, full of intrigue, confidence, and sexual energy, 29. They began a flirtation, often in front of Natalia, in English, which Natalia didn't understand. Little notes were exchanged in books. Shortly after the re-run of Stalin's show trial of Trotsky – properly arranged with US lawyers in the Casa Azul – found him resoundingly not guilty, Trotsky and Frida began their affair. In a further twist, Cristina consented to them using her house for their trysts. The danger of the affair – had his enemies found out they would have used it to totally discredit him – only added to its allure. Diego was oblivious, but Natalia found out and went into a terrible decline. A few weeks later Frida decided to end things. Trotsky begged her not to, but she stuck to her guns; she never loved Trotsky, it was just her bit of fun with a historical figure. A few months later she, somewhat teasingly, painted him a picture, a self-portrait, but, to his disappointment, didn't revive their dalliance.

WHERE?
FRIDA MEETING TROTSKY ON THE FREIGHTER
RUTH IN TAMPICO HARBOUR.
L TO R: NATALIA, FRIDA, TROTSKY AND SCHACHTMAN.

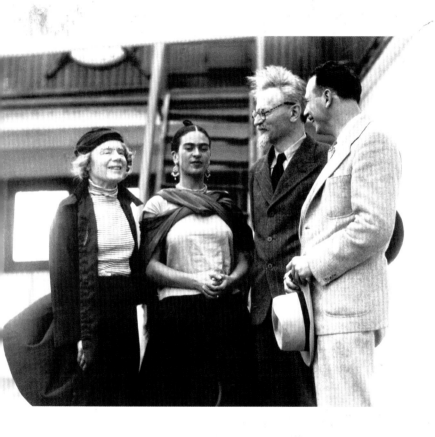

SELLING ART

Frida had largely been painting for her own gratification. She was also, at least publicly, very much in Diego Rivera's shadow. In typically '30s and '40s patronizingly sexist fashion, wherever Diego went, she would be referred to in the press as an accessory – "Mr Rivera's comely wife" was a typical construction. 'Comely' really isn't a word one would use of an artist who was creating pictures as disturbing as *My Birth*. But the fact remained that until Frida sold her work she wouldn't be considered as an artist in her own right. She recognised her first sale, to Hollywood film star Edward G. Robinson, as the breakthrough it was. Thereafter things happened in quick succession, with shows in Paris and in NYC. What mattered particularly was that these were sales to influential collectors. Throughout the process, Diego oiled the wheels: he recognised Frida's uniqueness as an artist, and wanted her to succeed independently of him. Neither he, nor her first patrons, could have imagined that one day she would completely eclipse the great man, not just in renown, but in the prices her paintings would achieve.

1

EDWARD G. ROBINSON

"...I am going to be able to be free, I'll be able to do what I want...without asking Diego for money." Frida

Frida's realism about her marriage, the confidence she drew from the seduction of Trotsky and a settled semi-independent life at the San Ángel house, resulted in a spurt of creativity and productivity. In 1937 and 1938, Frida produced over 16 works, including the masterpieces *Fulang-Chang and I* and *My Nurse and I.* Now, in addition to fearless honesty, Frida was revealing complex, ambiguous, psychological inner states of mind, with an alluring sexual undercurrent. These pictures grabbed the viewer. She was acquiring power as an artist, and she knew she had struck a chord, a rich vein. Rivera was in the background, encouraging her. Then in the summer of 1938, film star Edward G. Robinson, who was visiting Mexico, stopped by the San Ángel house. Diego showed him Frida's pictures. He bought four on the spot for $800 (around $15,000 today). This was a major breakthrough: Frida now could legitimately consider herself a professional artist.

WHO?
EDWARD G. ROBINSON WAS
A HUGE STAR IN THE 1930S AND 1940S.

Picturegoer
Film Weekly
3ᵈ

Ann SOTHERN
AND
Edward G. ROBINSON

②

ANDRÉ BRETON

"Mexico is the Surrealist locale, par excellence." Breton

André Breton, the 'Pope of Surrealism', arrived in Mexico in April 1938, to make contact with Trotsky. He stayed first in Mexico City with Diego's ex-wife Lupe Marín, and then for several weeks with the Riveras in San Ángel. Frida didn't really take to Breton, but she got on famously with his wife Jacqueline, a fellow painter. However Breton was mesmerised by Frida and, when he saw her pictures, instantly offered her an exhibition in Paris. For Breton she was a 'self-created Surrealist'. He was amazed to see how her work had blossomed into 'pure surreality....conceived without any prior knowledge of what I and my friends were up to'. He particularly admired the qualities of 'candour and insolence' in her work.

To have someone of the fame and power of Breton speak in these terms – an independent judge who always spoke his mind and suffered no fools – was another injection of confidence for Frida. She knew she was about to launch.

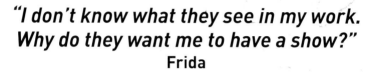

JULIEN LEVY, NYC

"I don't know what they see in my work. Why do they want me to have a show?"
Frida

Encouraged by Diego, Frida had participated in a group show at, according to Frida, a 'small and rotten place' (in fact the University Gallery in Mexico City). Julien Levy, who owned the smart Levy Gallery on the Upper East Side in NYC, which had recently featured surrealist works, happened to be in town, saw Frida's paintings and offered her a solo show at his gallery in October. He needed thirty or so works. Breton agreed to write the introduction to the catalogue, including the brilliant line that her work was 'like a ribbon around a bomb'. Diego gave a list of his New York connections for the invitations list, including the Rockefellers. Frida sailed for NYC in early October. At the opening she looked amazing in her Tehuana costume; there was a buzz about the show. She was featured in *Time* and *The New York Times* and three pictures were reproduced in *Vogue*. The exhibition was a triumph of publicity, and she sold half her paintings.

WHERE?
FRIDA FEATURED IN VOGUE, NOVEMBER 1938,
UNDER THE SLIGHTLY GALLING HEADLINE
'THE RISE OF ANOTHER RIVERA'.

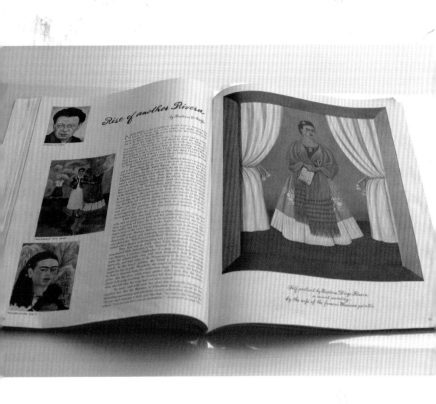

Self portrait by Madame Diego Rivera
a vivid painting
by the wife of the famous Mexican painter

91

4

FALLINGWATER

"Throughout his life, Kaufmann was a notorious philanderer." New York Times

In 1938 – a depression year – selling half a show was considered a success. What mattered more, however, was the calibre of people who bought Frida's work. Conger Goodyear, President of MOMA, wanted to buy *Fulang-Chang and I,* but it had already gone to Mary Schapiro Sklar; so he commissioned a similar work. Chester Dale – a recognised influential collector – bought a work. Wealthy department-store magnate Edgar J. Kaufmann Sr. (who had commissioned Frank Lloyd Wright to do his stunning house, Fallingwater) bought *Remembrance of an Open Wound.* Hyper-connected society photographer (*Vanity Fair, Harper's Bazaar*) Nickolas Muray bought *What the Water Gave Me.* Levy, who was falling in love with Frida, then arranged for them to go and stay at Fallingwater, to encourage Kaufman to become her patron. Frida flirted outrageously with the elderly Kaufman and his son. After a very late night, an exhausted and disappointed Levy headed up to his room. Much to his surprise he found a naked Frida in his bed waiting for him.

WHERE?
BEAR RUN,
STEWART TOWNSHIP,
FAYETTE COUNTY,
PENNSYLVANIA.

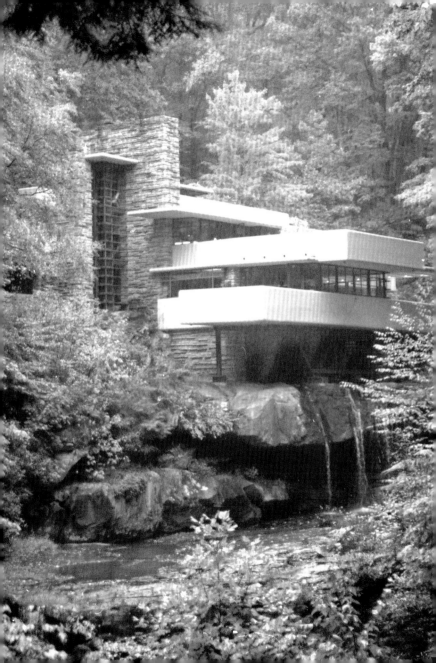

5

NICKOLAS MURAY

"I love you my Nick. I am so happy to think I love you." Frida

Trotsky and Levy, even if she did sleep with them, were in Frida's mind just flirtations. Nickolas Muray was a serious love affair. Uber handsome, urbane, well connected, a champion fencer and aeronaut, he counted Martha Graham, Eugene O'Neill, Jean Cocteau, Gertrude Vanderbilt Witney and Walter Lippmann amongst his friends. He had first met Frida in Mexico City in 1931, and they had had on-off laisons over the next few years when Muray was in town. He had also helped Frida with the prep for the Julien Levy show. However it was in the weeks Frida spent in New York that their relationship took on a passionate intensity, interrupted by Frida's trip to Paris. On her way back to Mexico, she returned via New York, only to realise that Muray had met someone else – Peggy Schwab, who would become his fourth wife a month later. Frida was devastated, but they remained friends. Muray did immortalise Frida better than anyone in the hundreds of brilliant portraits he took of her.

WHERE?
FRIDA AND NICK IN NEW YORK IN 1939.

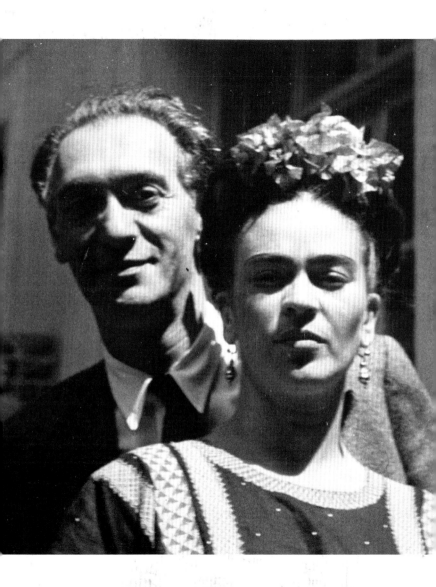

6

PARIS

"You have no idea what bitches these people are. They are so damned 'intellectual' and rotten. They make me vomit." Frida

Frida sailed for Paris, for the much vaunted show which Breton had promised, in January 1939. When she arrived she realised nothing had been organised. Her pictures were stuck in customs, Breton had not sorted a gallery, and it was only when she met Marcel Duchamp that anything happened: he arranged for the Pierre Colle Gallery – whose artists included Dalí – to show them. When Colle saw the pictures, he initially refused to exhibit most of them: too shocking, he said. To cap everything Frida, who was staying with the Bretons in their cramped apartment at 42 Avenue Fontaine, acquired a kidney infection; she ended up in the American Hospital. She was ready to give up and go home. Paris in 1939 was not the happiest place; Europe was in a state of unease, anticipating war, and Paris was full of impoverished Spanish refugees from Franco's Spain, which distressed her. With Diego's help she did manage to arrange for 400 to emigrate to Mexico.

WHERE?
CONTEMPORARY ILLUSTRATION OF
THE BOEUF SUR LE TOÎT NIGHTCLUB,
8TH ARRONDISSEMENT,
PARIS.

❼

PIERRE COLLE GALLERY

"People here are scared to death of war... the rich bitches don't want to buy." Frida

In the end Pierre Colle relented, and announced the show for 10th March. Frida moved out of the Bretons' to an apartment belonging to Marcel Duchamp's lover, the American collector Mary Reynolds. The show, labelled 'Mexique', was a critical success. The Louvre purchased *The Frame*. Kandinsky wept at some of her work. Joan Miró and Yves Tanguy (described by Frida as 'the big cacas' of Surrealism) congratulated her. The critics said it was brilliant. Most rewardingly she met Picasso, who gave her some hand-shaped earrings as a token of friendship. But the show was not a financial success and, partly as a result, a further show planned for the Guggenheim Jeune Gallery in London was cancelled. Frida enjoyed the beauty of Paris (in particular Place des Vosges), hung out with Surrealists Max Ernst and Paul Eluard and listened to Jazz at clubs like le Boeuf sur le Toît. As usual her style was fêted, not least by Schiaparelli, who was inspired to design the Madame Rivera dress for her 1939 collection.

WHERE?
PLACE DES VOSGES,
4TH ARRONDISSEMENT,
PARIS.

INDEPENDENCE

After the run of success with her work, Frida's return to Mexico should have been a happy time to reflect, paint and to enjoy living in the dual house. But it wasn't to be, and Frida once more moved back to the Casa Azul on her own: she and Diego had decided to divorce. The terrible war situation in Europe, which would soon involve the US, also meant that it was a rotten time to sell art. Frida had shows in London and New York cancelled. On top of everything else, her health took a turn for the worse; Frida was to find solace in drinking. To cap it all, the assassination of Leon Trotsky in his house, just around the corner from La Casa Azul, sent Frida into a state of shock. Diego decamped to San Francisco. Frida was to follow him there at the suggestion of Dr Eloesser. The rollercoaster ride was complete when, within the year, Diego and Frida decided to remarry.

DIVORCE

"...intimate reasons, personal causes, difficult to explain..."
Frida on her divorce from Diego.

On her return to Mexico City from Paris and NYC, Frida moved back into La Casa Azul: she and Diego decided to divorce. The reasons are not clear – was it her affairs – Muray? Or Trotsky? Or was Frida driving it, jealous of Diego's contact with Lupe, his ex-wife, or of his affair with film star Paulette Goddard? On balance it seems that Diego wanted it more, and Frida was too proud to fight. His declared reason – that he now had little to offer as a husband, given his philandering – sounds part humbug, part honest. Frida went into decline, saw no friends that she and Diego had in common and became lonely. Her terrible back pain returned and she developed a serious fungal infection on her fingers, making painting difficult. She turned to drink, sinking at one point to a bottle of cognac a day. To make matters worse, her doctor, Juan Farill, ordered an excruciating device with a 44 pound weight to stretch her spine. It didn't work. But through it all she continued to paint.

WHO?
DIEGO JUST LOVED HIS AMERICAN
EXCHANGE ART STUDENTS.

❷

WORKING ALONE

"I won't accept a damned cent from Diego. I will never accept money from any man until I die." Frida

Depressed, lonely, in terrible pain, on the edge of alcoholism: these proved great spurs to Frida's creativity. She knew that now she had to capitalise on her successful shows and paint, paint, paint. The results were brilliant – her masterpiece, *The Two Fridas*, was finished just as her divorce papers came through, then *Self Portrait with Cropped Hair* (symbolising the destruction of her femininity) and *Self Portrait with Monkey*. She also completed a commission from Clare Boothe Luce, *Suicide of Dorothy Hale*. Intended as a memorial to Boothe Luce's friend, it was instead a violent, alienating, visceral work which made Frida's patron physically sick when she opened it. Throughout this period her New York friends supported her: Nickolas Muray, Conger Goodyear and the Arenbergs all bought pictures. Levy offered another NYC show, but 1940 proved a difficult climate, and the show never materialised. Money was tight and her application for a Guggenheim Fellowship failed: they picked a now–forgotten artist instead.

105

❸

THE ASSASSINATION

"The whole situation, physically and morally, was something I cannot begin to describe." Frida

Trotsky and Rivera fell out whilst Frida was abroad. The Trotskys moved out of La Casa Azul in May '39, to a house nearby on Avenida Viena. They were still being pursued by Stalin's agents and on May 24th, 1940, at 4 am, their bedroom was machine-gunned by a gang that included David Siqueiros, a painter known to Frida and Diego. Amazingly the Trotskys survived. But Stalin had planted two conspirators in Trotsky's inner circle: his secretary, Sylvia Ageloff and her lover, posing as an admirer of Trotsky, the Catalan Stalinist Ramón Mercader. On August 20th at 5 pm he was let into Trotsky's study, hiding an ice-pick under his overcoat. He calmly walked behind Trotsky sitting at his desk and slammed the ice-pick into his skull. Trotsky died in hospital the following morning. Rivera fell under suspicion and quietly slipped out of Mexico to San Francisco. Frida was in a state of total shock. She had inadvertently befriended Mercader, whom she met in Paris, and had had him to dinner in Coyoacán. She was picked up by the police and held and interrogated for 48 hours.

WHERE?
THE DESK AT WHICH TROTSKY WAS ASSASSINATED,
IN HIS STUDY AT AVENIDA VIENA.

4

SAN FRANCISCO 2

"The risk of discovery only heightened the intensity of being together."
Heinz Berggruen

The Trotsky murder had indirect consequences for Frida and Diego. In San Francisco Diego, who had hired an armed guard, became very concerned about the stress Frida was under and went to consult Eloesser. His counsel was to get Frida to San Francisco immediately: apart from anything he questioned the quality of treatment she was receiving in Mexico. Surgery, in his view, was not the answer, but dealing with her underlying psychological condition was. He suggested a reconciliation: given their deep love, Frida could simply accept Diego's ways and subsume herself in work. Frida always listened to Eloesser. In September she flew to San Francisco and checked into St Luke's hospital. Eloesser recommended abstention from alcohol and electro therapy. After a month of treatment, Frida was on the mend. Whilst in hospital, Frida (33) conducted a passionate affair with a 25-year old German refugee and friend of Diego's, PR man Heinz Berggruen.

WHERE?
FRIDA,
PHOTOGRAPHED SHORTLY BEFORE HER AFFAIR WITH
HEINZ BERGGRUEN.

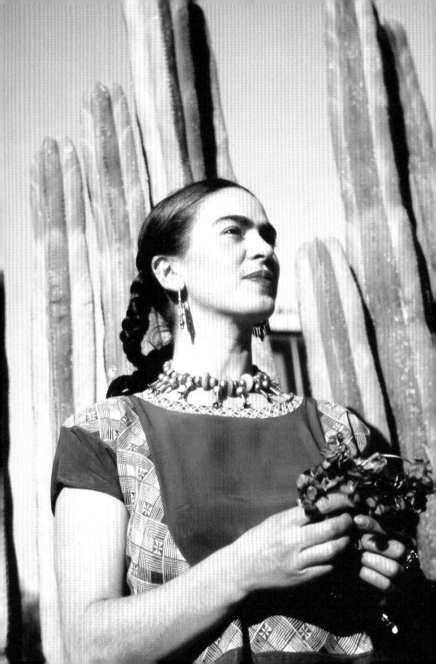

❺

"The separation...was having a bad effect on both of us." Diego

Diego had probably, for his own complex reasons, encouraged Berggruen in his seduction of Frida. Simultaneously he was using Eloesser as a go-betwen, asking Frida to remarry him. He knew her health was weak and in decline; Eloesser's judgement was that this was exacerbated by their divorce. However, once out of hospital Frida, at the invitation of Levy, went to New York. Berggruen had gone one day ahead. They holed up in the Barbizon-Plaza, where she and Diego had spent so much time. Frida and Berggruen partied hard with the Levy Gallery set. She was full of renewed energy and even returned to painting. Berggruen was totally infatuated, in love. Frida was slightly more clinical; she was revelling in life for a while, but after two months, she decided her destiny. She accepted Diego's proposal and returned to San Francisco. Berggruen never saw her again.

WHERE?
FRIDA LOVED GOING TO THE MOVIES IN NEW YORK.
TIMES SQUARE CINEMAS IN 1940, SHOWING JAMES
CAGNEY IN BOXING MOVIE *CITY FOR CONQUEST,*
AND *LONDON CAN TAKE IT!,* ABOUT LONDONERS'
RESILIENCE FACED WITH THE NAZI BLITZ.

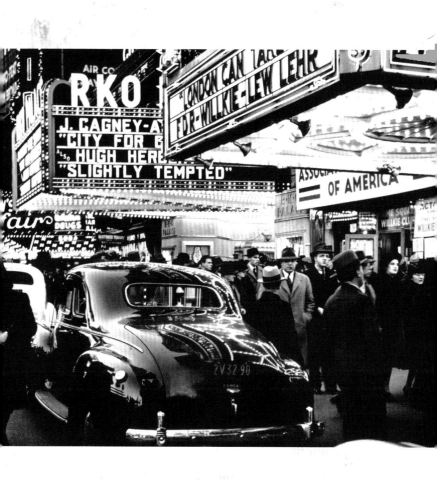

6

REMARRIAGE

"Dr. Eloesser...warned her...that I was an incorrigible philanderer...and would never change." Diego

Frida was back in San Francisco on November 28th, 1940. She and Diego were remarried on December 8th (Diego's 54th birthday; Frida was now 34) in a courtroom with just two friends: Arthur Niendorff (Diego's assistant) and his wife Alice. Frida, symbolically, wore a Spanish/Mexican costume. There was no party and Diego went back to work on his frescoes on Treasure Island the same day. There were certain stipulations for their renewed relationship: 1) No sex (Frida claimed that she would just imagine all of Diego's lovers in her place whilst they performed); 2) She would be self financing from sales of her paintings; 3) Diego would only cover one half of household expenses. Frida went home two weeks later, whilst Diego stayed to finish his mural, departing in February 1941, by which time – Mercader having been captured and sentenced to 20 years – Diego was no longer under suspicion for complicity in the Trotsky murder.

WHERE?
DIEGO AND FRIDA APPLYING
FOR A NEW MARRIAGE LICENSE
IN SAN FRANCISCO.

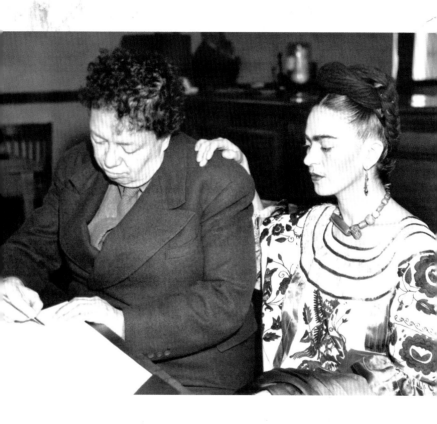

COYOACÁN

Back living together at La Casa Azul – the San Ángel house was now used as Diego's studio and occasional bolthole – Frida and Diego's relationship entered a rewarding phase, typified by their decision to construct an extraordinary museum to Diego's 'idols' – his collection of pre-Columbian works. Professionally, for Frida this was also a fruitful time. She was at last recognised in Mexico – long after she was recognised in the US – as a first rank artist, with honours including membership of the prestigious Seminary of Mexican Culture. Frida also became one of a group of illustrious teachers – a role she loved – at the new National Art School popularly known as La Esmeralda. Everything seemed to be coming together but, cruelly, Frida's health was now on the slide again. She suffered long periods of total exhaustion and very severe back pain, with a disrupted menstrual cycle, weight loss and weakness. Her various doctors had no cure and could not agree how to treat her condition. Hormone therapy did have some temporary positive results, but did not address the underlying causes.

❶

LA CASA AZUL 3

"I live the simplest life you can imagine... I just stay at home and paint monkeys."
Frida

It was both a new start and a return to familiar territory. Frida and Diego decided to move into La Casa Azul, whilst Diego kept San Ángel as his studio and occasional bachelor pad for future trysts with 'gringa' art students and tourists. The house was prepared for their new life: a studio for Frida and a huge bed in their bedroom, with shelves on which Diego could display his pre-Columbian artefacts. Frida, who began to refer to Diego as "The Big Child" adopted an almost motherly role. When Diego returned from San Francisco they would delight in discussing redecorations, instilling the house with the colours and motifs of Mexican peasant culture. Animating the house were Frida's chipmunk and her little parrot, Bonito. She was now painting almost every day. It was a very happy set-up, although Frida was conscious that her health was worsening. She was also depressed by the death of her father in April 1941, and by the state of the War. Some distraction was however provided by her new Spanish refugee lover, Ricardo Arias Viñas.

WHERE?
DIEGO AND FRIDA WITH ONE OF FRIDA'S MONKEYS
AT LA CASA AZUL.

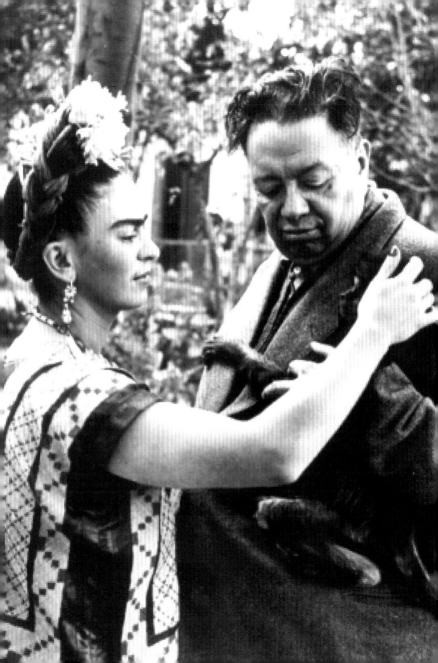

❷

ANAHUACALLI

"After his painting, what interests him most in life.....are his idols." Frida

Creating a rock-solid legacy of pre-Spanish Mexican culture was an attractive idea in 1942. Frida had never much liked US values, and Europe was tearing itself apart, with Nazism rampant. It was also an exciting project for Frida and Diego to do together, an affirmation of their second marriage. Diego had been collecting archaeological pieces since the 1920s, building a collection of 50,000 objects to rival that in the National Museum. The 'temple–museum' Diego designed was to be a home for his 'idols'. Frida sold her apartment on Insurgentes to help purchase a plot of land of volcanic rock just outside Coyoacán. Diego poured all his spare cash – money was tight as a result of the War – into the project. Frida spent days drumming up support from the Ministry of Education. Sadly they didn't live to see the project finished. It finally opened in 1964, completed by Juan O'Gorman (architect of the San Ángel house) and Heriberto Pagelson.

WHERE?
THE MUSEO ANAHUACALLI,
PEDREGAL,
MEXICO CITY.

❸

RECOGNITION

"I have painted little, and without the least desire for glory or ambition." Frida

For all her declared disdain for the US, it was there that Frida's unique brilliance was first appreciated. Mexico was slow to pick up. The 1940 Surrealism show in Mexico City, in which she exhibited, did not have the expected impact; no school of Mexican surrealists emerged. Critics suggested that was because life in Mexico was already surreal enough. She was now being asked to exhibit at prestigious shows in San Francisco, Boston, Philadelphia and New York. The acquired prestige in turn resulted in Mexico City galleries, rather late, beginning to ask Frida to show work. A crop of new galleries was emerging in the early '40s, and there was a move away from the mural tradition towards easel works. In 1942 Frida was one of 25 founder-member artists of the Seminary of Mexican Culture – very significant given that Mexico still had trouble appointing women to positions of power – and in 1946 she received a government fellowship and won a national arts prize. Frida, who had just had a further spine operation, went to receive her honour with her torso encased in a plaster cast.

WHAT?
SELF PORTRAIT WITH PARROT AND MONKEY,
FROM 1942.

❹

LA ESMERALDA

"Muchachos...let's go and paint the life in the streets." **Frida to her students**

As a further sign that Mexico had finally recognised her most original artist, Frida was invited to join the teaching staff (which included Diego) of the national School of Painting and Sculpture (colloquially know as 'La Esmeralda'). Frida loved teaching and her students adored the undidactic freedom she gave them to just create. Her pupils became know as 'Los Fridos'. She held lessons at La Casa Azul, where students were encourged to paint the monkeys, parrots, chipmunks and flowers. In an early precursor of street art, Frida also got some of her students to decorate the exterior of a pulqueria (traditional Mexican bar) called La Rosita, which attracted a celebrity opening and tons of press.Other commissions she obtained for Los Fridos polarised opinion, as they were suffused with Marxist revolutionary passion. Frida was readmitted into the Communist Party in 1948; even if her own work was apolitical, she encouraged leftism and *Mexicanidad* in her pupils. The Fridos eventually formed a group called the Young Revolutionary Artists.

WHERE?
FRIDA AND DIEGO, CONTENTED IN THE STUDIO AT LA CASA AZUL IN 1943. FRIDA HELD MANY OF HER ESMERALDA CLASSES HERE.

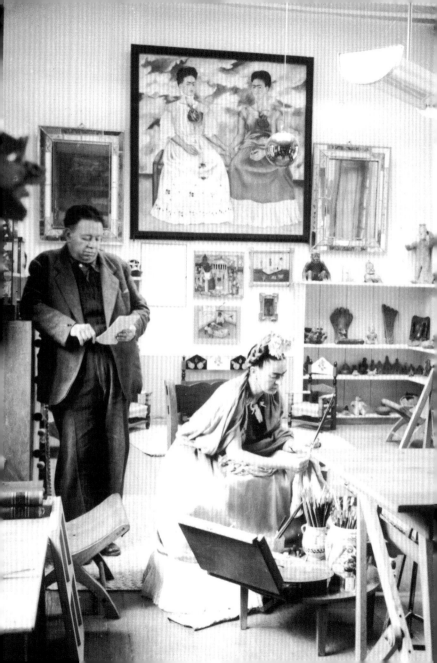

THE FADING OF THE LIGHT

In 1944, Frida's health once again took a turn for the worse. She reduced her teaching commitments and, under instruction from Dr Zimbrón, began to wear a steel corset. It alleviated her pain for a few months, but soon she was back in bed, not able to sit or stand. She had Lipidol inserted via a spinal tap, but mistakenly this was never removed, leading to terrible headaches. In June 1946 Frida went to New York to have an operation, which wasn't successful. Back in Mexico, she went through a series of 28 different types of corsets to help support her spine and alleviate her pain, to little avail. Through it all Frida continued to paint. The searing nature of her late works suggest that they were a form of therapy, or even *Schmerzlust* – seeking pleasure in pain. In 1950 Frida was back in hospital, where she would spend a year, being prescribed the highly addictive opioid, Demerol, to control her pain. It was the beginning of the end, which finally came in 1954, but not before one final remarkable exhibition and an anti-CIA demonstration with her Communist friends. Frida was so spirited, so brave, to the very sad and bitter end.

6

THE BROKEN COLUMN

"Each day I am worse...explain what kind of mess I have inside me and if it has a cure... or if death is going to take me."
Frida to Dr Eloesser.

In 1944 Frida's worsening health began slowly to overwhelm her. Her foot and spine were becoming much more painful. She was forced to wear a steel corset, prescribed by a Dr. Zimbrón. It worked for a while, but soon the pain was worse. She was then put onto Lipidol for her spine, but this only caused her more headaches. Her doctors tried 28 different orthopaedic corsets – plaster, leather and steel – in an attempt to alleviate her pain, but to no avail. Frida gave up teaching and turned to self-portraits as a way of processing her suffering. Intense images of Frida headless, footless, bleeding, cracked open, put us in no doubt as to what she was going through. On top of everything was the atrophy from inactivity and she was also losing weight fast. Frida had decided now that only an American doctor could save her. In June she flew, together with her sister Cristina, to New York.

WHAT?
THE BROKEN COLUMN.
ONE OF FRIDA'S MOST BRILLIANT IMAGES,
PAINTED IN 1944.

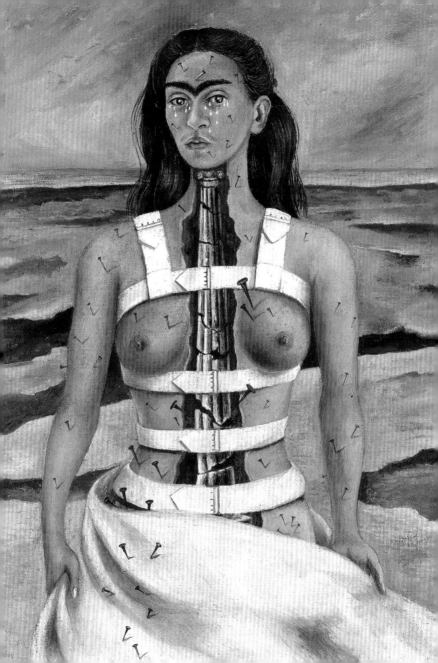

7

HOSPITAL FOR SPECIAL SURGERY

"The first two weeks were full of great suffering and tears..." Frida

Frida put her faith in Dr Philip Wilson, a bone specialist. He operated in June, fusing four vertebrae with bone from her pelvis; he also inserted a 6-inch steel rod into her spine. At first, the operation was a success. After two weeks Frida improved, and began drawing and painting again. By October, in much better spirits, she was back in Coyoacán, writing to patrons, discussing new commissions. But then the pain came back and Frida had to return to her bed and wear a steel corset again. Her medical history is ambiguous and incomplete; did Frida start doing too much? Did her fused vertebrae become unfused? Had Dr. Wilson inserted the rod in the wrong place? Was Frida also suffering from osteomyelitis, which attacks bone marrow, causing further bone deterioration? Her sense of despair was captured in her 1946 picture *The Little Deer*. The deer is shown running but pierced by nine arrows that will surely kill it. The deer has Frida's face.

WHAT?
ONE OF FRIDA'S MANY DEEPLY UNCOMFORTABLE
SPINE-SUPPORTING CORSETS,
NOW IN THE CASA AZUL MUSEUM.

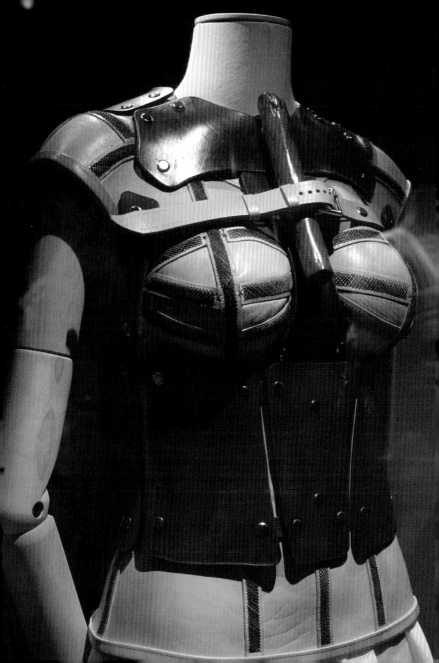

❽

THE ENGLISH HOSPITAL

"The highs and lows of Frida whilst in hospital depended on Diego's behaviour."
Dr Velasco y Polo

Frida had more spinal operations – none successful – in 1949. Then on 3rd January 1950, she woke to find that four toes on her right foot had turned black. She was back in hospital and gangrene was diagnosed, as was the treatment: amputation. She refused. Then she developed an absess under her spinal corset which became infected. Every morning she was injected with the antibiotic Terramycin. She did have her own room at least, which she decorated with candy skulls, white doves and the Russian flag. Diego took a small room next to Frida's where he slept most nights except for Tuesdays, when he would go to work at Anahuacalli. He hired a projector, to show her weekly movies. She had a streams of visitors, including prominent Mexican Communists. Her doctors had constructed an easel contraption over her bed so that when she felt up to it she could sit up and paint, sometimes for four or five hours a day. Frida spent a year at the English Hospital.

WHERE?
FRIDA PAINTING IN HER HOSPITAL BED
AT THE ENGLISH HOSPITAL.

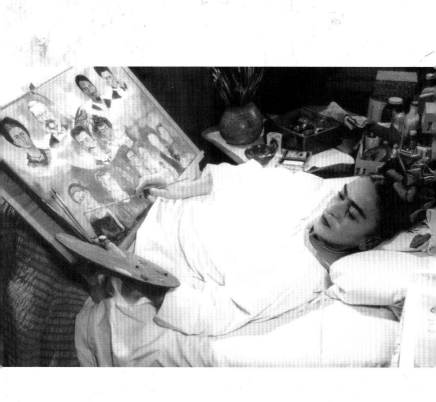

131

9

LA CASA AZUL 4

"I do not have pains. Only a weariness...and often desperation, a desperation no words can adequately describe." Frida

Dr Eloesser, Dr Zimbrón, Dr Puíg, Dr Velasco y Polo and Dr Juan Farill had done all they could for Frida, but they could not cure her. It was now a case of living with her condition, including a spinal plaster cast, and controlling the pain with Demerol. Frida went back to the Casa Azul. Nurses were hired, visitors came frequently and sometimes Dr Velasco would take her for a short spin in his convertible Lincoln Continental. But Frida was mostly confined to the house, to her bed or to her wheelchair. She would try and paint in the mornings and she had many visitors in the afternoon, but the underlying sense of despair at her situation was, like a shadow, always there. Very occasionally, if she had an 'up' day, she could manage a restaurant outing. She became intensely close to a few women friends, some she occasionally slept with, encouraged by Diego. She suspected Diego of having an affair with one of these friends, Raquel Tibol, who had rejected a pass from Frida, and in a fit of jealousy tried to hang herself from the canopy over her bed.

WHERE?
FRIDA IN HER CASA AZUL STUDIO,
WITH DR JUAN FARILL.

132

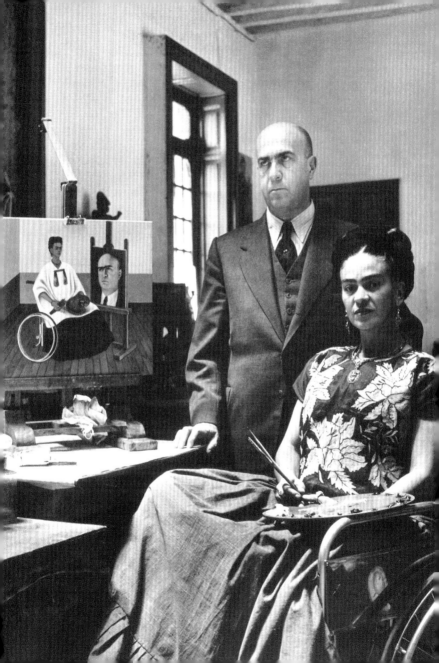

10

GALERÍA ARTE CONTEMPORÁNEO

"It is impossible to separate the life and work. Her paintings are her biography."
Time

Frida's first and only solo show in Mexico was the idea of the renowned Mexican photographer, Lola Álvarez Bravo. Frida's doctors had said she was far too ill to attend, so Lola decided to include Frida's four poster as the centrepiece of the show, a symbol of her absence. But Frida had other ideas. At the vernissage in April, as a huge crowd gathered outside, the sound of sirens was heard and an ambulance appeared. A few minutes later, Frida was stretchered in, dressed in her Mexican costume, and placed in the bed. Frida herself had become art. She lay there, drugged, exhausted, but enthralled, savouring her triumph. Frida would have loved the macabre overtones: she was clearly close to death, yet holding court. Admirers came to greet her, to touch her, as though paying their final respects, and, in medieval fashion, as though her touch might bring them luck. The show was a triumph, garnering international interest, briefly turning Frida into a global celebrity.

WHERE?
THE CONTEMPORARY ART GALLERY,
CENTRAL MEXICO CITY, MEXICO.

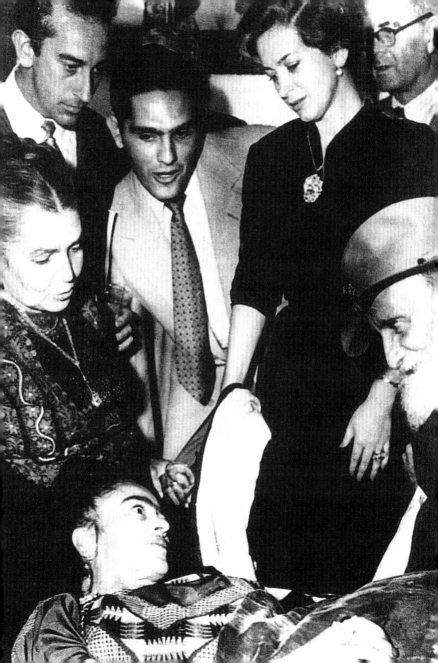

11

A VERY SILENT EXIT

"I hope the exit is joyful – and I hope never to come back." Final entry in Frida's diary.

Frida had initially refused to have her leg amputated. By August 1953, Dr Farill decided that it was now urgent. Frida was finally resigned to the operation. After she lost her leg, she was listless, not wishing even to see Diego. Back home, she tried to commit suicide. Frida refused initially to wear an artificial leg. Diego, painting frantically to pay for her nurses, would hold vigils by her bed. After three months she rallied, and even managed to walk a little, but then relapsed. Her drugs were causing wild mood swings: euphoria followed by hysteria. Some days she managed to paint, strapped by a sash to her chair. She became passionate about her Communism: ex-voto images of Marx and Stalin (unfinished) were to be among her last works. She developed bronchopneumonia, but insisted on attending, on July 2nd 1954, an anti-CIA, Communist demonstration in her wheelchair. On July 12th Frida fell asleep as usual, Diego beside her, at around 11pm. He left to spend the night in his studio. At 6am on the 13th a nurse went to check on her. Frida Kahlo, her eyes open in a fixed stare, had died quietly, alone, in the night. The official cause of death: pulmonary embolism. But her diary entry suggests otherwise.

WHERE?
FRIDA'S STUDIO IN THE CASA AZUL.
UNFINISHED PORTRAIT ON HER EASEL.

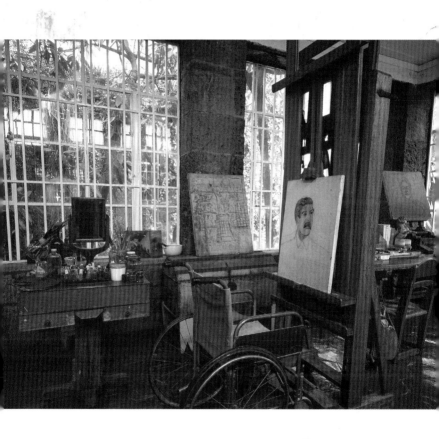

SAINT FRIDA

At 6.30 pm on the day following her death, Frida Kahlo lay in state in the lobby of Mexico's Palace of Fine Arts. Her coffin was draped with the Communist Flag, hammer and sickle on a white star. Former President Lázaro Cárdenas formed one of the honour guard. 600 people came to pay their respects before she was cremated on July 14th. Then there was a period of calm and in 1958, the Casa Azul reopened as the Frida Kahlo Museum. For the next twenty years it received a small, steady stream of visitors; Frida was known by a modest number of enthusiasts, but no more. But Frida Kahlo was, posthumously, about to surprise us all once again. In the 1970s she became of interest to feminist scholars, who questioned the lack of female representation in the Western art canon. Prices of Kahlos started creeping up at auction, but still only selling for $19,000 in 1977 ($80,000 today).

Then things began taking off. In 1978 the Palacio de Bellas Artes in Mexico City held a retrospective, which travelled to Chicago the same year. 1982 saw Whitechapel Gallery's retrospective of Frida's works and Tina Modotti's photos. Hayden Herrera's brilliant, definitive biography was published in 1983 and in 1984 Mexico, late in the day realising what a brilliant treasure they had on their hands, declared Frida's works national cultural heritage, forbidding their export. By 1990, Herrera's biography had been optioned by Hollywood and the same year, Frida became the first Latin American artist to break $1 million at auction with *Diego and I*, which achieved $1.43 million at Sotheby's. In the late 1980s Madonna, slightly ahead of the curve as so often, bought *My Birth*. She was later to add four more Kahlos to her collection, including the stunning *Self Portrait with Monkey* from 1940; the cover to her album *Rebel Heart* was directly inspired by a photo of Kahlo. Frida was

approaching sainthood. She was now known by her first name only. The 2002 movie of the same name, produced by Nancy Hardin, released by Miramax, and starring Salma Hayek, had a budget of $12 million and achieved $56 million at the box office. In 2006 her painting *Roots*, from 1943, achieved $5.6 million at auction, followed by her all-time high, *Two Lovers in a Forest* (1939), which sold for $8 million in 2016.

In 2012 Camille Paglia, the smart doyenne of feminist theory had declared that Frida Kahlo was 'the patron saint of feminist art historians'. And saintly she has become, a talisman, a cult figure, like so many medieval saints, who endured her pain, with a brutal honesty that makes her other-wordly. She is not just a role model for feminists, but for humanity. When we look at her images, we *feel* her pain, we *live* her suffering. And like all saints, we have started to mythologise her, to rewrite her history to suit the cult of Frida that we have created. As with all saints, the facts don't really matter that much.

And the cult goes from strength to strength. In the era of introspective social media, gender politics, and endless selfies, there is something about Frida that is more relevant than ever. She was all carefully constructed image, but also all self-reflective honesty. She was utterly sexy, but utterly, uncompromisingly herself, painting every hair of her 'Zapata' moustache, or of her magnificent unibrow. She suffered terribly, but lived life fearlessly, sucking every drop of intrigue from it. And her art is clever, but also immediate, perfect for an impatient generation of worshippers. Since 2000 there have been over 80 exhibitions worldwide to Frida, with one major one opening as I write, and with many more planned. Frida Kahlo lives amongst us now, more powerfully than ever.

TEMPLES TO FRIDA

"As an icon...Kahlo is arguably the most portrayed and reproduced artist of all time." The Telegraph

When the art world canonises its heroes it doesn't hold back. Ignored apart from a few savvy collectors during her lifetime, quietly appreciated only amongst the cognoscenti for twenty or so years, Frida could have disappeared into quiet obscurity, a curiosity in Mexico City. How things have changed. The world's major art galleries now can't get enough of her. Their often grandiose neo-classical structures celebrate her life in huge sell-out exhibitions. Adherents of her work queue for hours, patiently, to feel Frida's emotions, to experience Frida's magic. The Palacio de Bellas Artes, Mexico City; The National Museum of Women in the Arts, Washington D.C.; The Haupt Conservatory, New York Botanical Gardens; SFMOMA, San Francisco; The Musée de l'Orangerie and The Grand Palais, Paris; the Martin Gropius Bau Museum in Berlin; Tate Modern and the Victoria and Albert Museum, London – these are but a few of the temples that have allowed us to pay homage. There are many smaller shrines – clever art galleries – the world over that allow us to access the cult. Frida is the art phenomenon of our era.

WHERE?
A HUGE QUEUE FOR THE FRIDA SHOW IN 2007 SNAKES
AROUND THE PIAZZA IN FRONT OF THE PALACIO DE BELLAS
ARTES, MEXICO CITY.

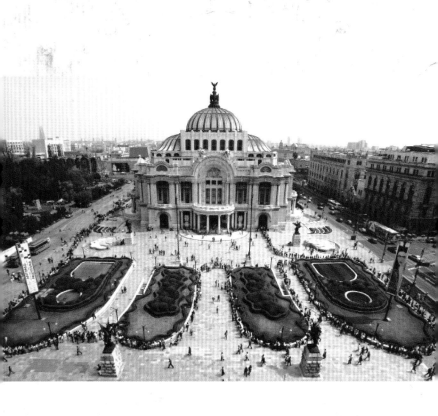

EXHIBITIONS

It seems that Frida Kahlo is everywhere in exhibition form. It is hard to identify one major art centre around the world which hasn't had a Frida show. The map shows only exhibitions since 2000. No other artist, man or woman, has had this global impact, this very broad reach. With every year that passes, Frida seems to be more relevant than ever. Rivera was brilliant, but Frida, who exhibited so modestly during her life has, in death, eclipsed him completely.

● **NORTH AMERICA**
Calgary, Canada, *Frida Kahlo: Her Photos*; **Phoenix**, *Frida Kahlo and Diego Rivera*; *Frida Kahlo: Her Photos*; **St Petersburg, FL**, *Frida Kahlo at the Dali*; **Tucson AZ**, *Frida Kahlo: Art, Garden, Life*; **Toronto**, *Frida & Diego: Passion Politics and Painting*; *Frida Kahlo: Through the Lens of Nickolas Murray*;

New York, *Frida Kahlo: Art, Garden, Life*; *Mirror Mirror, Portraits of Frida Kahlo*; **Detroit**, *Diego Rivera and Frida Kahlo in Detroit*; **Fort Lauderdale FL**, *Kahlo, Rivera + Mexican Modern Art*; **Belton Texas**, *Frida Kahlo: Through the Lens of Nickolas Muray*; **Chicago**, *Unbound*; **Long Beach CA**, *Frida Kahlo: Her Photos*; **Toronto**, *Frida and*

Diego: Passion Politics and Painting; **Kansas City**, *Kahlo, Rivera + Mexican Modern Art*; **Atlanta Georgia**, *Frida and Diego: Passion Politics and Painting*; **San Diego,** *The Complete Frida Kahlo*; *Frida and Me;* **San Antonio, TX** *Diego y Frida: Una sonrisa a mitad del camino*; **Los Angeles**, *Frida Kahlo: Her Photos*.

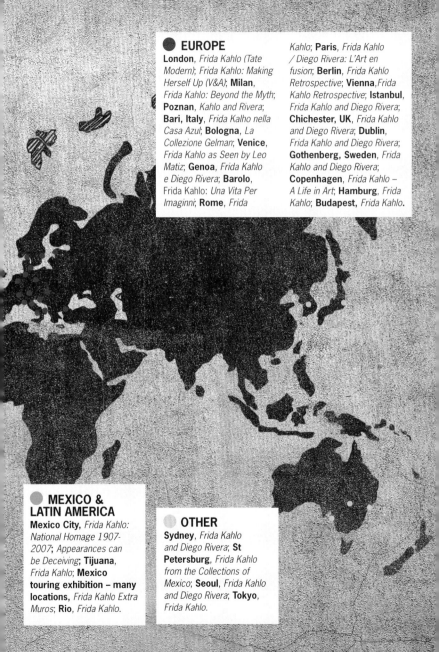

EUROPE

London, *Frida Kahlo (Tate Modern)*; *Frida Kahlo: Making Herself Up (V&A)*; **Milan**, *Frida Kahlo: Beyond the Myth*; **Poznan**, *Kahlo and Rivera*; **Bari, Italy**, *Frida Kalho nella Casa Azul*; **Bologna**, *La Collezione Gelman*; **Venice**, *Frida Kahlo as Seen by Leo Matiz*; **Genoa**, *Frida Kahlo e Diego Rivera*; **Barolo**, *Frida Kahlo: Una Vita Per Imaginni*; **Rome**, *Frida Kahlo*; **Paris**, *Frida Kahlo / Diego Rivera: L'Art en fusion*; **Berlin**, *Frida Kahlo Retrospective*; **Vienna**, *Frida Kahlo Retrospective*; **Istanbul**, *Frida Kahlo and Diego Rivera*; **Chichester, UK**, *Frida Kahlo and Diego Rivera*; **Dublin**, *Frida Kahlo and Diego Rivera*; **Gothenberg, Sweden**, *Frida Kahlo and Diego Rivera*; **Copenhagen**, *Frida Kahlo – A Life in Art*; **Hamburg**, *Frida Kahlo*; **Budapest**, *Frida Kahlo*.

MEXICO & LATIN AMERICA

Mexico City, *Frida Kahlo: National Homage 1907-2007*; *Appearances can be Deceiving*; **Tijuana**, *Frida Kahlo*; **Mexico touring exhibition – many locations**, *Frida Kahlo Extra Muros*; **Rio**, *Frida Kahlo*.

OTHER

Sydney, *Frida Kahlo and Diego Rivera*; **St Petersburg**, *Frida Kahlo from the Collections of Mexico*; **Seoul**, *Frida Kahlo and Diego Rivera*; **Tokyo**, *Frida Kahlo*.

PAINTINGS

In 1984 the Mexican government declared Frida a national treasure, which meant that her work could not be exported outside the country. Most of her works are therefore in Mexico City – at the Museo Dolores Olmedo, the Gelman Collection and at La Casa Azul. Dolores Olmedo, a hugely wealthy property magnate and good friend of Rivera's, built up a magnificent collection of Rivera's work before he died, to which she added many Kahlos (she and Frida did not get on) almost as an afterthought; she reputedly paid Rivera just US$1,600 for the Kahlos. Other significant paintings are in private hands in the USA, notably with Madonna, who shrewdly bought four before prices really rocketed. There are next no Kahlos in Europe, and only one in a museum. Those curators sometimes get it very wrong.

USA

SAN FRANCISCO
Wedding Portrait, SF MOMA.
Portrait of Dr Eloesser, University of California School of Medicine.
Mrs Jean Wright, Collection of John Berggruen.
My Dress, Hoover Gallery.
Four Inhabitants, Palo Alto.

NEW YORK
My Birth, Madonna Collection.
My Grandparents, MOMA.
What the Water Gave Me, Isadore Ducasse Fine Arts.
Self-Portrait with Cropped Hair, MOMA.
Fulang-Chang and I, MOMA.

WASHINGTON DC
Self Portrait, National Museum of Women in the Arts.
Two Nudes, Sold for record US$8 million by Jon Shirley (Microsoft) in 2016. Private collection.

MONTERREY, CA
Girl with Death Mask, private collection.

MADISON, WI
Sill Life, MMoCA.

PHOENIX, AZ
Suicide of Dorothy Hale, Phoenix Art Museum.

BUFFALO, NY
Self Portrait with Monkey, Albright Knox.

AUSTIN, TX
Self Portrait, Harry Ransom Center, University of Texas.

HOUSTON, TX
Little Deer, Farb Collection; *Roots*, Lubetkin Collection.

BOSTON, MA
Two Women, Museum of Fine Arts; *Self Portrait*, private collection.

DALLAS, TX
Self Portrait, Very Ugly, private collection.

NEW ORLEANS, LA
Me and My Parrots, Harold H. Stream Collection.

DES MOINES, IA
Self Portrait Loose Hair, Des Moines Art Center

LOS ANGELES, CA
Weeping Coconuts, LACMA.

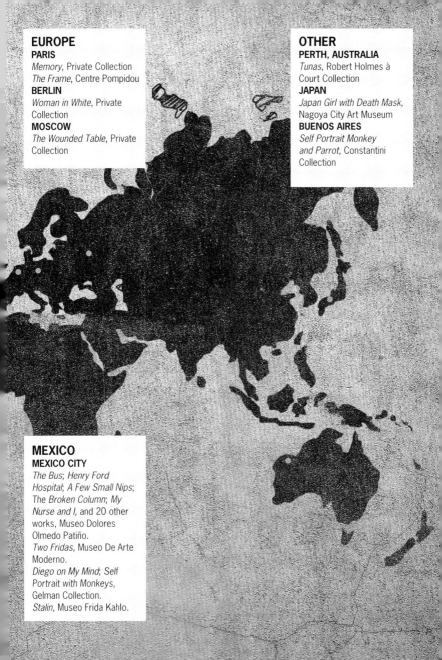

EUROPE
PARIS
Memory, Private Collection
The Frame, Centre Pompidou
BERLIN
Woman in White, Private
Collection
MOSCOW
The Wounded Table, Private
Collection

OTHER
PERTH, AUSTRALIA
Tunas, Robert Holmes à
Court Collection
JAPAN
Japan Girl with Death Mask,
Nagoya City Art Museum
BUENOS AIRES
*Self Portrait Monkey
and Parrot*, Constantini
Collection

MEXICO
MEXICO CITY
The Bus; *Henry Ford
Hospital*; *A Few Small Nips*;
The Broken Column; *My
Nurse and I,* and 20 other
works, Museo Dolores
Olmedo Patiño.
Two Fridas, Museo De Arte
Moderno.
Diego on My Mind; *Self
Portrait with Monkeys*,
Gelman Collection.
Stalin, Museo Frida Kahlo.

PENSARON QUE FUI SURREALISTA PERO NO LO FUI. NUNCA PINTÉ SUEÑOS. PINTÉ MI PROPIA REALIDAD.

THEY THOUGHT I WAS A SURREALIST BUT I WASN'T. I NEVER PAINTED DREAMS. I PAINTED MY OWN REALITY.

FRIDA KAHLO

CREDITS

Photo credits below are listed in section and page title order. Graffito wishes to thank all individuals and picture libraries who helped track down often elusive images.
In credits below, Alamy = Alamy Stock Photo.

BEGINNINGS
Baden Baden Alamy
La Casa Azul I Alamy
Mexico City Mme B. Cendrars
The Photographer Alamy
Rewriting History Alamy
Revolution Alamy
Polio Alamy
La Preparatoria Mme B. Cendrars
Meeting Rivera Alamy
The Accident Alamy
Aftermath Rex Features
Frida in Mexico City Mme B. Cendrars

MEETING DIEGO
Tina Modotti's Parties Alamy
The Ministry of Education Alamy
Communista Alamy
Casa de Cortés Alamy
La Campesina Alamy
Cuernavaca Alamy
Tehuana Rex Features

AMERIC
San Francisco Alamy
Dr. Eloesser Getty Images
Atherton Getty Images
New York Rex Features
The Barbizon Rex Features
Detroit Rex Features
Grosse Pointe Rex Features

The Henry Ford Hospital Rex Features
New York 2 Rex Features
Rockefeller Center Rex Features
Eighth Street Getty Images
Frida in the USA Karen Wilks

RETURN TO MEXICO
San Ángel Alamy
Hospital Again
Avenida Insurgentes Alamy
San Ángel 2 Rex Features
La Casa Azul 2 Getty Images
Trotsky Alamy

SELLING ART
Edward G. Robinson Alamy
André Breton Alamy
Julien Levy, NYC Rex Features
Fallingwater Rex Features
Nickolas Muray Alamy
Paris Alamy
Pierre Colle Gallery Alamy

INDEPENDENCE
Divorce Getty Images
Working Alone Alamy
The Assassination Alamy
San Francisco 2 Getty Images
Berggruen Alamy
Remarriage Getty Images

COYOACÁN
La Casa Azul 3 Getty Images
Anahuacalli Rex Features
Recognition Cover Images
La Esmeralda Getty Images

THE FADING OF THE LIGHT
The Broken Column Cover Images
Hospital for Special Surgery Rex Features
The English Hospital Cover Images
La Casa Azul 3 Rex Features
Galeria Arte Contemporaneo Rex Features
A Very Silent Exit Rex Features

SAINT FRIDA
Temples to Frida Rex Features
Exhibitions Karen Wilks
Paintings Karen Wilks

A note on the author.
Of Anglo-Spanish parentage, Ian Castello-Cortes grew up in South America and Cambridge, England. He is a publisher and writer with a particular interest in contemporary counter-cultures. Ian studied Modern History at Oxford University.

First published in the United States of America, November 2018.
Gingko Press, Inc. 1321 Fifth Street, Berkeley, CA 94710, USA
First published under license from Graffito Books
ISBN: 978-1-58423-698-6
Printed in China
© Graffito Books Ltd, 2018. www.graffitobooks.com.
This is not an official publication. The contents, analysis and interpretations within express the views and opinions of Graffito Books Ltd only. All images in this book have been produced with the knowledge and prior consent of the picture libraries and photographers concerned.
Art Director: Karen Wilks **Copy Editor:** Serena Pethick **Managing Editor:** Anthony Bland